Painting
Seascapes *In Oil*

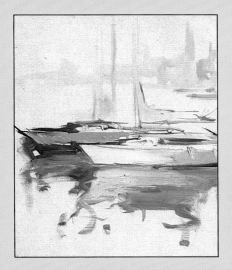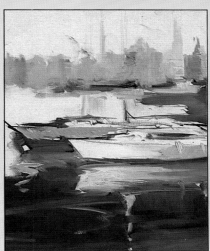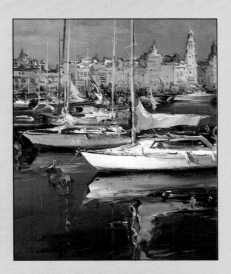

JOSE M. PARRAMON

Watson-Guptill Publications/New York

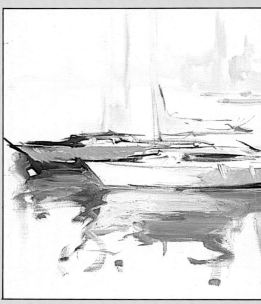

Copyright © 1988 by Parramón Ediciones, S.A.

First published in 1990 in the United States by Watson-Guptill
Publications, a division of BPI Communications, Inc.,
1515 Broadway, New York, New York 10036.

Library of Congress Cataloging-in-Publication Data

Parramón, José María.
 [Pintando marinas al óleo. English]
 Painting seascapes in oil / José M. Parramón.
 p. cm.—(Watson-Guptill painting library)
 Translation of: Pintando marinas al óleo.
 ISBN: 0-8230-4732-6 (paperback)
 1. Marine painting—Technique. I. Title. II. Series.
 ND1370. P3713 1990
 751.45'437—dc20 90-12550
 CIP

Distributed in the United Kingdom by Phaidon Press Ltd.,
Musterlin House, Jordan Hill Road, Oxford OX2 8DP.

Manufactured in Spain
Legal Deposit: B-23.684-90

1 2 3 4 5 6 7 8 9 / 94 93 92 91 90

Painting
Seascapes *In Oil*

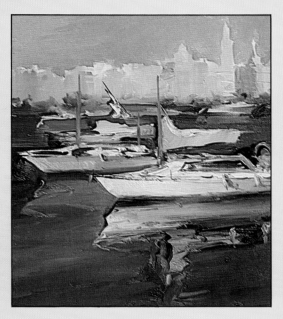
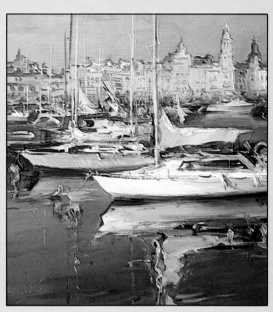

The Watson-Guptill Painting Library is a collection of books aimed at guiding the student of painting and drawing through the work of several professional artists. Each book demonstrates the techniques for working in a specific medium—watercolor, acrylic, pastel, colored pencil, oil and so on—as applied to a specific theme, such as landscape, still life, figure, portrait, and seascape. Each book in the series has an introduction followed by lessons in painting the subject in question. In the introduction of this book, you will start developing the theme with an in-depth study of construction, perspective, contrast, atmosphere, and reflections. Moreover, in each volume the techniques, tools, and materials used for the medium in question are reviewed. (In this book, you will learn about formal and chromatic interpretation.)

Perhaps the most extraordinary aspect of this book is the way in which each lesson—the choice of theme, the composition, the color interpretation and harmonization, the effects of light and shade—is explained and illustrated line by line, brushstroke by brushstroke, step by step, with numerous photographs taken while the artist was painting the picture. And, all of the artists included share with you their cumulative knowledge and experience—professional techniques, secrets, and tricks that will prove invaluable.

I personally directed this work with a team that I am proud of, and I honestly believe that this book really teaches you how to paint.

José M. Parramón

Fundamental knowledge: drawing, construction

It is necessary to have some basic knowledge of materials, media, and techniques if you wish to paint or draw. Many people believe that painters are gifted, "inspired by the muses," and work without effort as if it were as natural as eating and sleeping.

But of course, this is not true. Artists are people who have a special sensibility that enables them to imagine, compose, draw, and paint a picture. All of this can be achieved through constant observation and practice. But this capacity cannot be gained without solid grounding in the fundamentals of drawing.

Michelangelo, who studied with Donatello, told his students: "I shall teach you everything I know with one word: Draw!"

Indeed, drawing is the foundation of all fine arts. And the secret of learning to box and proportion brings to mind the words of Cézanne to his friend and student Emile Bernard: "Look at nature as if it were in the shape of a cube, sphere, or cylinder, all in correct perspective."

In effect, the process to follow in order to draw any object is to imagine it situated within a basic form that best synthesizes it —a cube, pyramid, prism, cone, sphere, or other geometric figure.

What about a seascape; can it be reduced to a series of basic forms as well?

Certainly; a seascape (which does not necessarily have to be a large expanse of sea) is no exception to this rule. Rock formations, typical fishermen's houses, all kinds of embarkations, fishing tackle, and the countless other elements that could be included in a seascape can all start from a series of basic forms. The examples on the following page are sufficient proof of this.

But first you must know how to draw the basic geometric forms correctly, from any viewpoint and in any position. In order to do this, you need to learn the basics of perspective.

Fig. 1. Starting off with these basic forms, you should remember what Cézanne once said, "Look at nature as if it were in the shape of a cube, sphere, or cylinder, all in correct perspective." Practice drawing these shapes, memorizing if possible their light patterns and shadows in different positions.

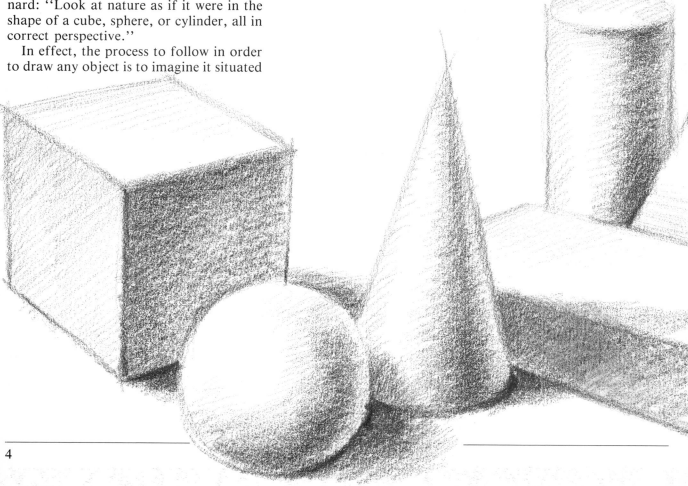

1

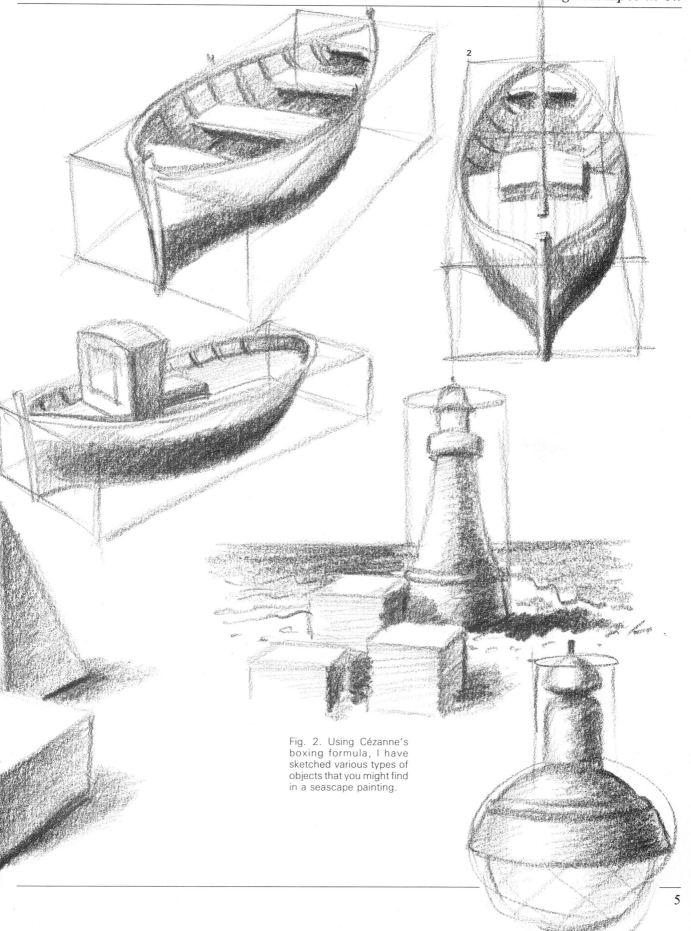

Fig. 2. Using Cézanne's boxing formula, I have sketched various types of objects that you might find in a seascape painting.

Basic elements of perspective

In drawing such things as a shoe box, a cup of coffee, or an enormous lighthouse that dominates the coastline—or even a collection of things that you might find on a desk or maybe a complicated-looking rock formation on a cliff—you must realize that everything you draw is reduced to a structural problem that requires you to know the basics of perspective. There are many complex rules in drawing, but for landscape and seascape painters, these laws can be simplified to one or two fundamental facts.

The horizon line

In theory, the horizon line is an element of perspective that exists in all themes, though it is more predominant in some themes than in others. The horizon line is the real or imaginary horizontal line situated in front of the painter at eye level.

If you are facing the sea, there is no doubt as to where the horizon is: It is a horizontal line that separates the sea from the sky, which in a picture would be situated according to the position of the painter. For example, from a sitting position on the beach, you would see a very narrow stretch of sea (low horizon); standing on top of some rocks, you would see a much greater expanse of sea (high horizon). In the first example, a boat in the foreground would interrupt the horizon; in the second example, the boat would be below the horizon line.

Point of View (PoV)

This is the point that indicates where the painter is looking. It is situated on the horizon line at the halfway point; to avoid a symmetrical drawing you can displace it to either side of the picture.

3

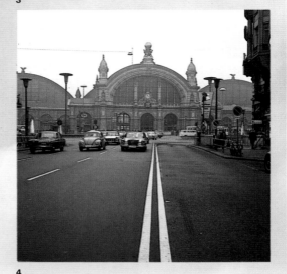

Fig. 3. This photograph of the Kaiserstrasse, which leads to the central train station in Frankfurt, West Germany, is an excellent example of one-point parallel perspective.

4

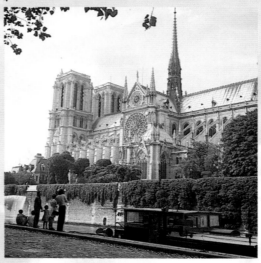

Fig. 4. By looking at the photograph of the cathedral of Nôtre Dame in Paris, with the adjacent plan, you can see how easy it is to determine the horizon line (at eye level, looking forward). You can also see the vanishing points in oblique perspective on both sides.

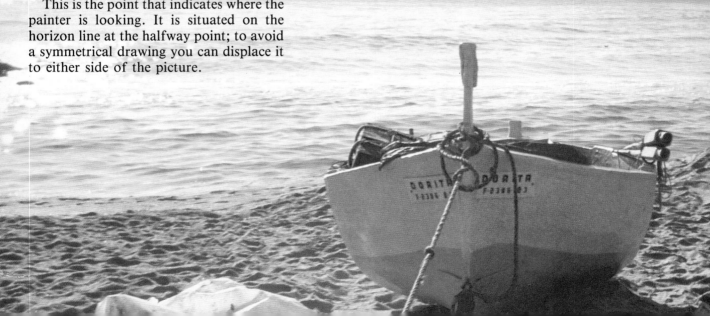

Vanishing points (V.P.)

Vanishing points are always found on the horizon line. They are the points at which receding parallel lines appear to converge at the horizon; such convergence creates the idea of depth, or a third dimension. Imagine, for example, a set of railroad tracks diminishing in size as they recede toward the horizon.

The two formulas of perspective that are used most often in artistic drawing are:

—**the one-point parallel perspective**
—**the two-point oblique perspective**

(There is also a *three-point perspective,* but it is seldom used in fine art drawing.)

In fig. 5, you can see the application of the parallel and oblique formulas in the picture of various prisms and cubes. But allow me to explain more extensively these formulas when they are applied to seascape themes.

Fig. 5. A classic example of the horizon line at eye height is where the sea meets the sky—as you can see in the photograph at the bottom of the page. In your own time, check the form of the cubes in parallel perspective (A, B, C) and in oblique perspective (D, E), with the lines meeting their corresponding vanishing points: One point for the parallels, and two points for the obliques.

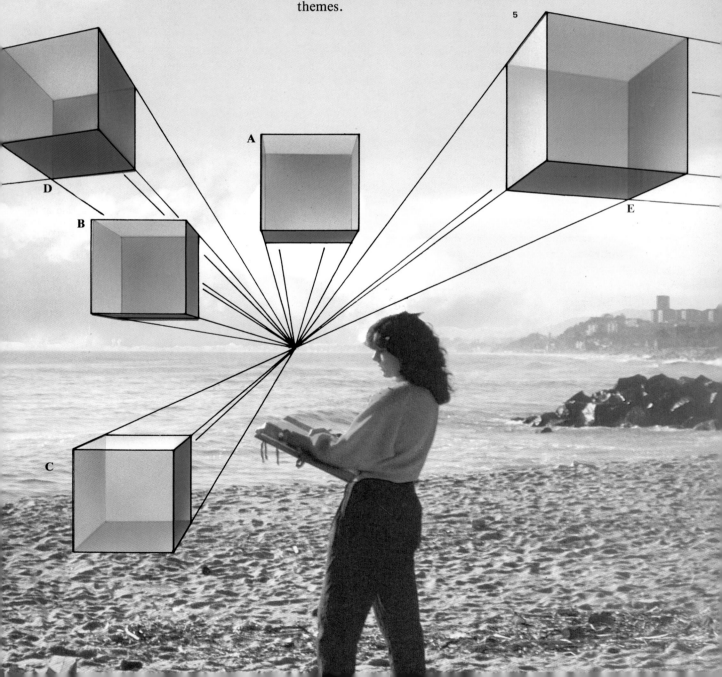

Parallel perspective

The cube and the square are perfect forms with which to develop all basic shapes: the rectangular prism, the circle, the cylinder, the cone, the pyramid, even the sphere. We will start off with the cube in order to draw and box other forms. In the diagram below, you can see how a cube is drawn in parallel perspective.

First, you must establish the horizon line and draw under it, or above it—it has the same effect (fig. 6A). Then, you must indicate the vanishing point (V.P.)—remember, you need only a single vanishing point for parallel perspective—which will coincide with the point of view. Next, you will sketch four lines that extend from the four angles of the square (fig. 6B) to the vanishing point.

Roughly sketch in line *a,* which outlines the upper side of the cube, and then sketch in line *b,* thus completing the form (fig. 6C).

Have you finished? Not yet. Try to imagine that the cube is made of transparent glass, and draw lines *c* and *d* so you can check that the proportions of the cube are correct (fig. 6D). You will see that the form can become a cube with six equal squares or a parallelipiped, which is a rectangular prism. In figs. 7 and 8, you can see that the rough calculation in line *a* is incorrect for drawing an equal-sided cube, and as a result a prism is obtained.

With a square you can also obtain a prism, a circle, and a cylinder. You can see this process in figs. 9 to 12. Note how simple the process is to follow; you can draw a perfect circle by hand, from which a cylinder and a cone can be developed.

Now draw squares, cubes, cylinders, and other forms in parallel perspective; then draw boats, houses, streets, towers, or any objects you might include in a seascape painting within those forms.

At the end, take note of some of the most common errors that arise from drawing the base and upper side of a cylinder (figs. 11 and 12).

Figs. 6A, B, C, and D. In order to draw a cube in parallel perspective, start by drawing the horizon line and determining the point of view, which at the same time will be the vanishing point (V.P.). Then, draw a corresponding square—the near side of the cube (fig. 6A). Next, draw four lines from the four corners of the square to the vanishing point (fig. 6B). Now, draw in the horizontal line A as well as the vertical line B, which establishes the depth of the form (fig. 6C). At this point, you can say that the form is finished. But now sketch in lines C and D, as if the form were totally transparent, to check if the proportions are correct (fig. 6D).

Figs. 7 and 8. Here you can see the common error that can be made in calculating the placement and distance of the horizontal line A (fig. 7). This kind of error can be detected when the form is viewed as a glass "cube" (fig. 8).

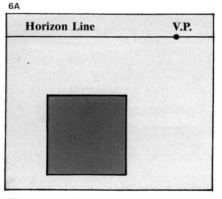

6A

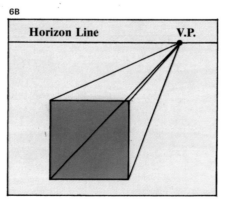

6B

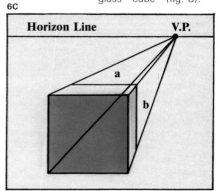

6C

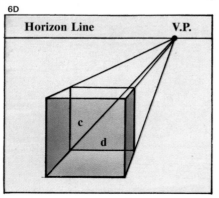

6D

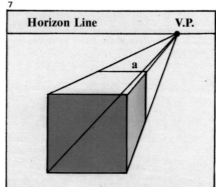

7

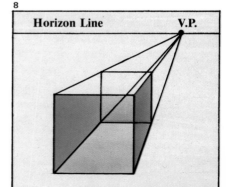

8

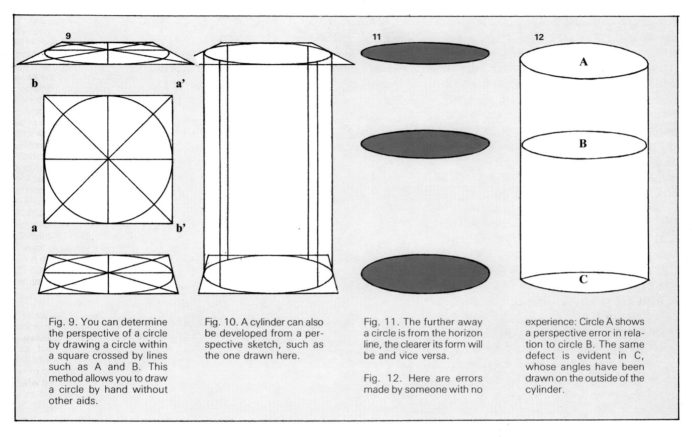

Fig. 9. You can determine the perspective of a circle by drawing a circle within a square crossed by lines such as A and B. This method allows you to draw a circle by hand without other aids.

Fig. 10. A cylinder can also be developed from a perspective sketch, such as the one drawn here.

Fig. 11. The further away a circle is from the horizon line, the clearer its form will be and vice versa.

Fig. 12. Here are errors made by someone with no experience: Circle A shows a perspective error in relation to circle B. The same defect is evident in C, whose angles have been drawn on the outside of the cylinder.

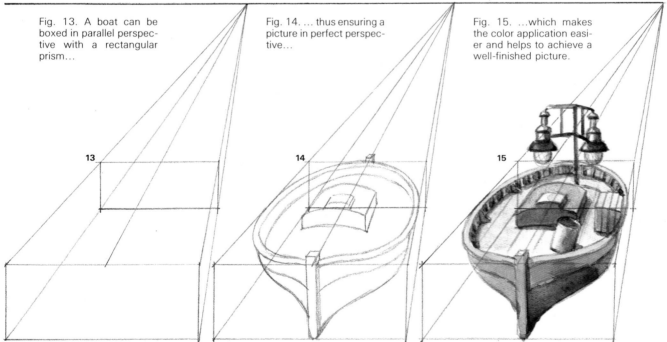

Fig. 13. A boat can be boxed in parallel perspective with a rectangular prism...

Fig. 14. ... thus ensuring a picture in perfect perspective...

Fig. 15. ...which makes the color application easier and helps to achieve a well-finished picture.

Oblique perspective

As you know from the previous lesson, the parallel perspective of a cube is achieved with one vanishing point, which is also the point of view, and a single series of lines to create depth.

However, it is more common to see two sides of a prism or a cube in an oblique position, with two series of lines; each series of lines disappears at its own vanishing point. In this lesson, you will be drawing a cube in oblique perspective (figs. 16A, B and C).

Before you begin, it is important to remember that a 90° angle is formed at the base of a cube. Try not to forget this rule, because a cube that boxes an object such as a boat or a boathouse with a sharp angle measuring less than 90° at the base, is a deformed cube and will deform the object (see figs. 17A and B).

To avoid this trap, you should take the two following rules into account:

1. **Do not draw the cube very high above, or below, the horizon line.**
2. **Do not place the two vanishing points too close to each other.**

But if you paint your landscapes in the open air, drawing and painting before the model, such deformations are impossible. The two vanishing points will not be near each other; on the contrary, they will be so far apart that they will be outside the picture. In order to work out the perspective of a landscape without vanishing points, the expert artist draws a guideline that allows him to draw in lines and forms in correct perspective.

Let me say in finishing that the artist has to create and draw without making bothersome, tedious calculations. Therefore, you can roughly calculate the placement of the horizon line and the point of view and vanishing points and still be working within the rules of perspective.

Figs. 16A, B and C. In these diagrams, you can see how to draw a cube in oblique perspective. Start first by placing the horizon line and the two vanishing points, then draw the central vertical line *a* (fig. 16A). Sketch the vanishing lines to their corresponding points and draw in vertical lines, *b* and *c*, which then completes the two near sides of the shape (fig. 16B). Finish by drawing in the vanishing lines *d* and *e*, which create the top part of the cube (fig. 16C), and then draw the lines of the posterior sides—representing a transparent cube—which will allow you to check for correct proportions.

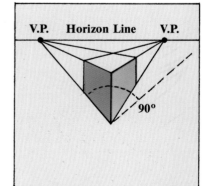

Figs. 17A and B. It is important to remember that in oblique perspective, the angle formed by the base of the cube should be 90°. To avoid this error, do not draw the cube very high, or low, from the horizon line. Also, do not draw the two vanishing points too close to each other.

16A

V.P. Horizon Line V.P.

a

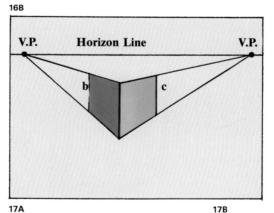

16B

V.P. Horizon Line V.P.

b c

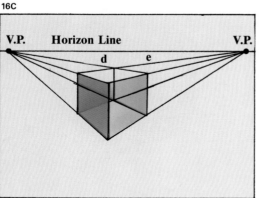

16C

V.P. Horizon Line V.P.

d e

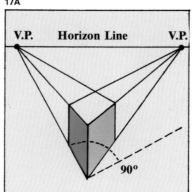

17A

V.P. Horizon Line V.P.

90°

17B

V.P. Horizon Line V.P.

90°

18

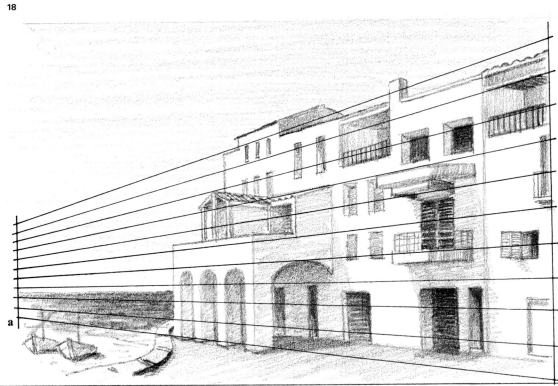

Fig. 18. When you are drawing or painting in the open air, the vanishing points will be outside the picture frame. In such a case, you must roughly calculate the upper and lower vanishing lines by sketching vertical lines in equal parts (lines *a* and *b*). Then, you need to make a rough guideline in order to determine the inclination and vanishing parallels in respect to the horizon.

a

b

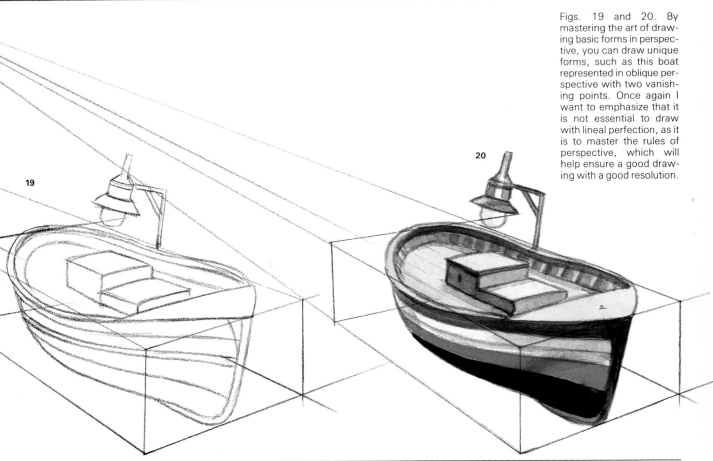

Figs. 19 and 20. By mastering the art of drawing basic forms in perspective, you can draw unique forms, such as this boat represented in oblique perspective with two vanishing points. Once again I want to emphasize that it is not essential to draw with lineal perfection, as it is to master the rules of perspective, which will help ensure a good drawing with a good resolution.

19

20

Light and shadow

The time of day, as well as the subject's position with respect to the sun, will determine whether the light is *frontal, lateral,* or *backlighting* (which has two variants: *frontal lateral* or *semi-backlighting*). The least appropiate time of day to paint is midday, when the sun is at its highest point and the subject receives light from directly above, a rather disagreeable type of illumination.

Frontal lighting eliminates most shadows and highlights colors, making it more pictorial than lateral lighting or backlighting, in which the play of light and shadows accentuate a subject's volume. Frontal lighting emphasizes *colors,* while lateral lighting emphasizes *values.* Backlighting creates predominant shadows and a halo of light that separates and profiles shapes, making it ideal for poetic interpretations of subjects using a flat and broken color range.

The quality of the light—whether it is *diffuse* or *direct*—is also important. Diffuse light occurs when the sun is half-covered by clouds; under such conditions, all colors become grayed and their strength reduced. This effect is more pronounced when the sky is totally covered with clouds, and more still when it rains. With diffuse lighting, you should use a broken range of gray colors mixed with white as well as two complementary colors in unequal proportions. *Direct light* occurs when the sky is clear. Colors appear intense and saturated, inviting the use of a luminous palette of bright, vivid colors.

The effects of light and shadow must also be considered with factors such as the condition and the different sides of the model. You must understand that: The areas where the *light* strikes the subject will emphasize the subject's true *color;* the *shadow* corresponds to the area opposite the light, in which blue should always be used; the *reflected light* is a type of shadow with light, the result of the shadow's color mixed with the color of the subject that is creating the reflection; and the *projected shadow,* which appears on the surface of the subject, is a shadow that mixes the color of the surface with the shadow color, blue.

Is that everything? No. The effects of light and shadow always affect the contrast, which whether intense or soft is an essential part of a landscape theme. I will discuss *contrast* and *atmosphere* on the following pages.

Fig. 21. Venice, Italy. Lateral lighting is good for "documenting" the subject, to see the most evident forms. It is perfect lighting to paint the dimensions and the volume of the subject matter.

Fig. 22. Here is another view of figure 21. Backlighting tends to obscure the subject's volume, but it offers more expressive possibilities that can develop into more creative results.

21

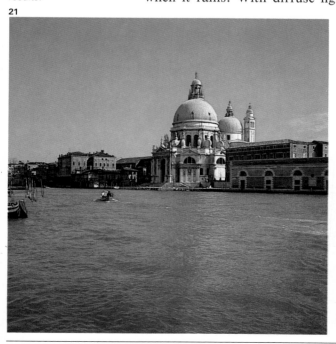

22

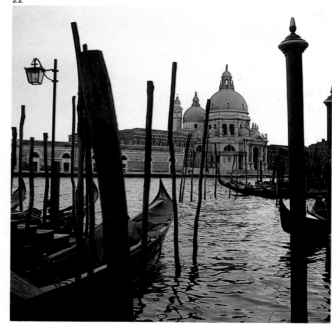

Contrast

If you paint a boat on a light blue sea and the same boat on a dark blue sea, the latter will appear lighter than the former and vice versa (figs. 23 and 24). This phenomenon is an example of the *law of simultaneous contrasts*, which is defined as follows:

A color becomes darker when the color surrounding it is lighter, and a color becomes lighter when the color surrounding it is darker.

Try to remember this rule when you want to highlight a form. Separate the form you want to highlight by darkening or lightening the color surrounding it. As a result, you will create a simultaneous contrast between the form and background.

Another phenomenon known as *the law of the induction of complementary colors* is also important to remember:

To modify a color, you can change the color that surrounds it to its complementary color.

In this respect, Delacroix's famous saying comes to mind: "Give me mud and I will paint the skin of Venus...as long as I can paint the colors I desire around her."

But the first and most important factor in creating contrast in a painting is the *juxtaposition of complementary colors*.

<div align="center">

Yellow - Deep blue
Magenta - Green
Red - Medium blue

</div>

The basic pairs of complementary colors listed above and other pairs derived from them were used by the postimpressionists as well as by the fauvists—first by van Gogh and Gauguin and later by Vlaminck and Matisse. The artists working in this manner painted pictures that created shock and scandal because of their use of colors and contrasts.

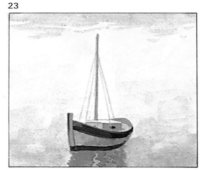

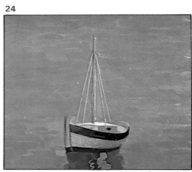

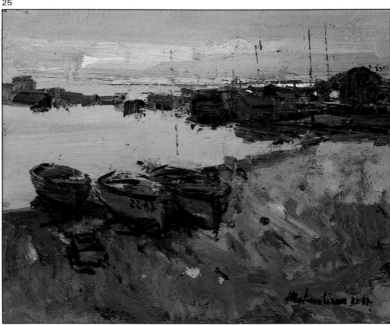

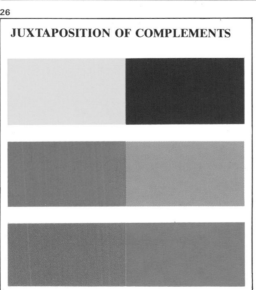

JUXTAPOSITION OF COMPLEMENTS

Figs. 23 and 24. The law of *simultaneous contrasts* is demonstrated here with a boat surrounded by a light background that makes the boat appear darker, and the same boat with a dark background that makes it appear lighter.

Fig. 25. Martínez Lozano, *Marina*, private collection. This is a magnificent example of contrasts produced by the juxtaposition of complementary colors.

Fig. 26. A juxtaposition of two complementary colors creates a maximum color contrast.

Atmosphere

In contrast to sculpture, which is three dimensional, painting has only two dimensions, width and height. The third dimension —depth—has to be represented in a painting: **a)** with linear perspective, which defines an object's volume; **b)** with the effects of light and shadow, which determine an object's volume; **c)** by contrast and atmosphere, which create the feeling of space and depth. Of the three items mentioned above, contrast and atmosphere are the factors that most directly relate to the use of color in a painting.

All themes, especially seascapes, allow for the representation and accentuation of the contrast and atmosphere factor. In a seaport during the first hour of the morning when the sun is still low, it is easy to see a contrast: the foreground with lively colors against the background colors that are diluted.

In regard to this matter, the philosopher Hegel, in his work *System of the Arts,* has expressed his views, which I have paraphrased as follows:

As a general rule, the layman in art believes that the foreground is darker and the background is lighter. In reality, the foreground is darker and lighter at the same time; the contrast of light and shadows is more intense because of their proximity to the painter, and at the same time the contours are sharper.

While contemplating this, you should read Leonardo da Vinci's *Treatise of Painting.* A brief summary of his ideas on this matter is as follows:

All parts of the subject matter nearest the viewer must be finished with great application. The painting must develop according to the position of the different planes: a simple and precise foreground, with the successive planes becoming more vaporous and less precise in the distance.

To create the illusion of depth in a painting, keep these factors in mind:

1. **Create a lively color contrast in the foreground in relation to the planes that recede into the background.**

27

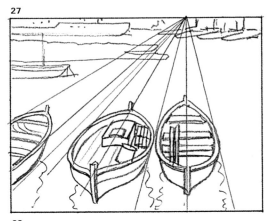

28

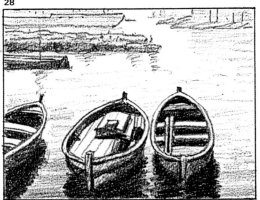

29

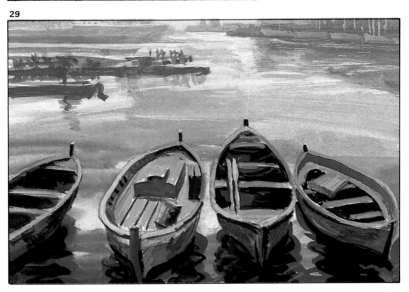

Figs. 27 to 29. There are three fundamental ways to create depth in a painting: *perspective* (fig. 27), in which you situate the forms in space with a series of lines, according to your point of view; *lights* and *shadows* (fig. 28), which give volume; and *atmosphere* (fig. 29), which is developed through color contrasts.

2. **Gray the colors you use on successively receding planes.**
3. **Emphasize sharpness in the foreground and soften the receding planes.**

Reflections

Seawater acts like a mirror; it reflects light and thus reproduces images that are in or floating on the water. When water moves slowly, as in the case of a port or embarkation, the reflected images create optical illusions. When the water has a restless motion the reflected images are in an inverted position. In any case, I do not believe that this will be a problem for you when painting or drawing images or forms that are reflected in the water. When I paint in front of the subject matter and copy it exactly as I see it, I usually have no problems.

There is, however, a rule related to the perspective of reflected images, which is important to remember:

Reflected forms have the same vanishing point as their original forms.

Therefore, a reflected image is not a duplicate of the original, due to the fact that: *The lines of the reflected forms are directed to the vanishing point in a more oblique way,* which makes them more inclined. As a result, the effect is accentuated, especially in a vertical subject. For example, look at the main posts of the boats in the picture below; they appear inclined in the reflections in the water. The reflections of the posts are longer toward the spectator and shorter when they recede toward the background.

30

Fig. 30. Reflections are another perspective problem which an artist solves with rough guessing. Remember, reflected forms have the same vanishing point as their original forms.

15

Going out in search of the motif

Pere Lluís Via was born in 1948. From the age of about ten to seventeen he attended a drawing academy in his native small town.

Via mostly paints rural and urban landscapes, but he also paints seascapes. His work has been exhibited in the United States and Spain.

Formats

"When a novice painter begins," Via says, "he usually paints in small formats. But there comes a time when he feels he needs more space in which to develop his painting. I feel much better with large formats; with a large space, I can better develop my artistic temperament."

On page 30 is a chart indicating dimensions and examples of the figure, landscape, and seascape formats. The smallest format that Via uses is the no. 8. From there he goes to nos. 10, 20, 60, 80, 120, and even larger. He usually works with a figure format. He does not like the seascape format, not even for seascapes. Sometimes he paints pictures that are outside the standard formats. For example, he likes the square format: Some of his works are 79″×79″ (2×2 m) or even 98″×98″ (2.5×2.5 m).

Painting indoors or outdoors

"In order to paint seascapes, you must go outside. I never paint seascapes in the studio, unless there is a problem with size and transport. In such a case, I paint from a smaller picture that I have previously painted outside. I do an enlargement of the smaller version. But I never work with a normal-size format in the studio. I always go out to paint the theme first."

As with the impressionists, Via is also inspired by nature: "It really motivates me," he says. And he goes on to say that he is totally against what most painters do today: take photographs or slides of the subject to paint from.

"That's terrible. Photos or slides, no matter how good they are, can never give you the color you saw while viewing that particular seascape. As a painter, you also fail to produce the true color, or the color of

reality at that moment. The true color can only be produced by being there. My interpretation of the color is inspired by the true color. No one sees a color in the same way: The same seascapes can be painted with different colors by different artists. But I need to see reality in front of me, so I can give my own color interpretation of that reality."

I can sum up by saying that the painter does not use any intermediary aids between reality and his interpretation of it.

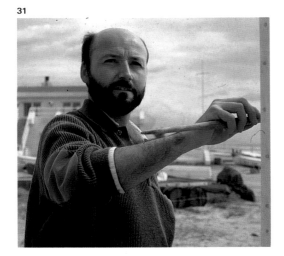

31

Fig. 31. Painting is a constant exercise in creativity and in the search of one's own style. Pere Lluís Via has found his. If you look at his work reproduced on the next page, you will agree that his seascapes possess an undeniable personality.

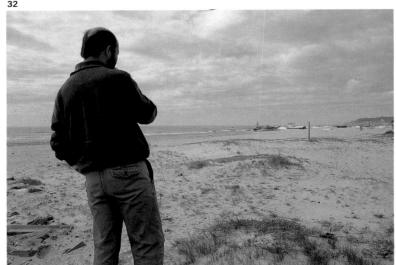

32

Fig. 32. Via is an outdoor painter; he doesn't like painting landscapes or seascapes in the studio. He believes the artist must interpret the "climate" of the motif in nature which, depending on the light, will allow him to paint not only one picture, but several. The artist stops along the beach and thoughtfully contemplates what seems to be a good motif: In front of him, he sees a great expanse of sand, interrupted here and there by tufts of grass and pieces of brick; at the far end, there are some boats, a distant hill, and the sea.

Unusual Seascapes

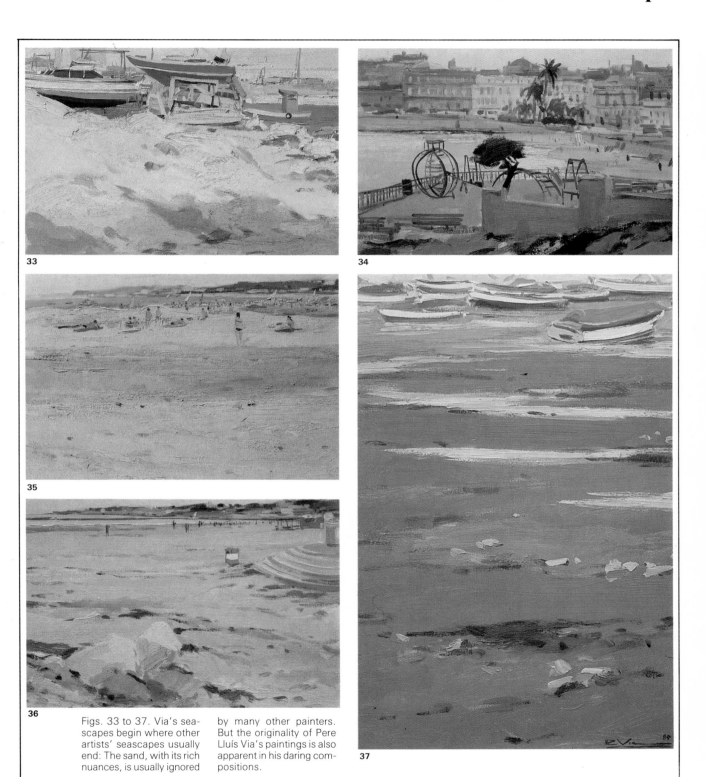

Figs. 33 to 37. Via's seascapes begin where other artists' seascapes usually end: The sand, with its rich nuances, is usually ignored by many other painters. But the originality of Pere Lluís Via's paintings is also apparent in his daring compositions.

Composing the motif

Via is distinguished, up to a certain point, by his rather unusual compositions. The artist says he prefers to choose simple themes and work hard on them:

"I always start my seascapes where most painters would usually finish their seascapes; I start with that extension of sand, that piece of land that most painters would leave out of the painting. Because sand is difficult to paint, I find it challenging and am attracted to it. Painting boats is easy, but it's not so easy to paint different shades of an expanse of sand. That's what's interesting for me."

Via says there are some painters who calculate their compositions by using the golden number principle, which states that there should be the same proportional relationship between the smallest and largest parts of a painting that exists between the largest part and the whole.

Is it possible that Via has distorted this principle by taking the golden number to its limits?

"Yes," he admits, "you could say that I believe in the principle of a greater and lesser part. But taking it to its limit. Sometimes I have even passed this limit, leaving most of the painting as sky or sand."

But for now, from the pictures you see on this page, Via appears eclectic and moderate. He decides on no. 20 figure format; the size of the canvas will be $28^3/_4'' \times 23^5/_8''$ (73 × 60 cm).

The choice of motif

The first thing Via does is walk along the beach in search of his motif. "It's one of the few beaches where you can still find fishing boats, not sailboats or launches."

The sky is partly cloudy but clear, giving a slight gray light. He thinks the colors will be interesting, probably very transparent.

The artist looks over the motif, which he has already chosen in his head. He moves further back to a position which he envisions in his painting.

He continues to walk around the area until he comes across a corner that is relatively separate from the first line of the beach. Via seems to be satisfied.

38

39

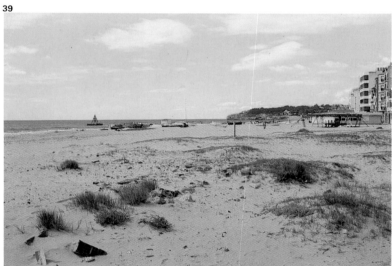

Some recognizable elements can be seen from the painter's position that can be used in the picture: There are several boats, a refreshment stand that is not in use because the tourist season has not started yet, a block of cement...

Figs. 38 and 39. The above photographs were taken in the same place, but the views are totally different. They could be used for two completely distinct paintings. The bottom one was taken following the golden number principle: There is the same relationship between the smallest and largest parts that exists between the largest part and the whole. In the top photograph, the golden number principle has been distorted and exaggerated; this is the compositional motif Via chooses.

A limited palette is sufficient

In the foreground of the picture there are some weeds:

"It's always good to have some kind of element to work on in the part of the composition nearest the painter in order to give it some visual interest. I like these very much," he says, pointing to some pieces of brick and cement in the sand. "The most difficult thing to achieve with brushstrokes is the small details of the sand. If I wanted to create more problems for myself, I'd paint a large expanse of sand without any other elements of reference."

Sometimes Via paints, as van Gogh did, two or three pictures a day. "Often I take two or three canvases and paint the same motif at different hours of the day, under different light."

The painter is satisfied with his choice for the composition. He goes to fetch his painting equipment from the car. "The most important thing is to situate yourself with your back to the sun."

Via takes out the palette, paints, and solvents, and erects the easel. Then, he fastens the canvas, prepares the palette, and pours turpentine into a glass container.

This is what Via's palette looks like, from left to right.

white
ultramarine blue
lemon yellow
light yellow ochre
yellow ochre
vermilion
carmine
light green

"I like to use a very limited number of colors, and I never use black or brown. I like to create my own tones, using only one or two colors instead of tones that are commercially manufactured."

When it comes to paintbrushes, Via uses thick ones.

He paints directly on the white of the canvas, just at it comes from the art store without any background color.

Fig. 40. After selecting the motif and choosing the composition, Via sets up his outdoor easel, which can be folded up and easily transported.

Fig. 41. Via has a very austere palette. But it is enough to obtain all the colors and tones he needs. The artist prefers to mix his colors in order to get various tones.

40

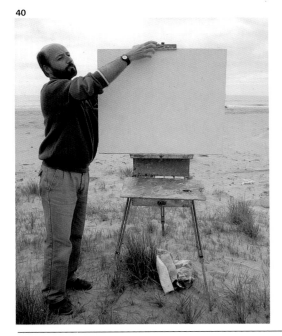

41

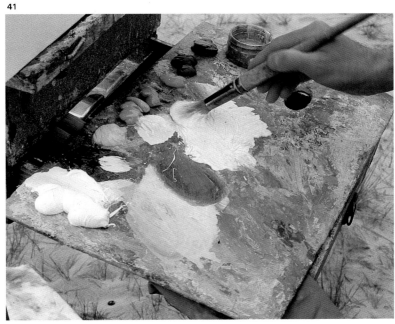

First stage: the whole beach

Via starts by mixing a small amount of ultramarine blue with an abundance of white, then a little light yellow ochre, and some vermilion. All of those colors mixed together give him a light brown tone with a light mauve tendency. He then proceeds to apply it to the upper right-hand part of the canvas.

The brush he uses does not have a number because it is an industrial brush. As you can see in the photograph, it is a very thick brush (fig. 42).

With care, he establishes a lightly inclined line at the upper part of the picture. This distinguishes the proportions of the various parts of the painting.

Via defines the boundary between the mountains and the sea by introducing new colors, including a fair amount of ultramarine blue and yellow ochre, which produces a broken green.

He continues to mix with his thick brush and now produces a warmish gray hue that, before reaching the canvas, is transformed into a sandy tonality.

Afterward he changes his brush.

"Because the brushes I use are thick and my color impastos are also thick, everytime I want to introduce a new color, I have to change brushes. This way the new color comes out clean."

Via is now painting a wide area, though not all in the same color. He works different areas, establishing tones and shades. By adding one color and then another here and there, he gradually covers the area.

For example, the color is slightly warmer and darker in the lower part than in the center: He used more vermilion in that area. With some slightly darker tones, he introduces color variations in the areas that have already been painted until the painting is filled with color, except for the top space, especially the left side, which remains untouched.

You can see three distinct areas in the treatment of the sand: the darkest tones are in the background, the light tones are in the center, the medium tones are in the foreground.

Figs. 42 and 43. Via begins painting with thick brushes and abundant color. First, he paints what constitutes the largest area of the picture: the sand. However, as you can see, it is not a uniform color.

Fig. 44. Using ultramarine blue, vermilion, light yellow ochre, and a lot of white (half the palette), Via applies the first tones with brushstrokes of thick coats of paint. This first tonal application will not differ greatly from the finished painting.

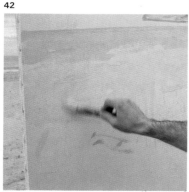

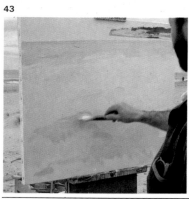

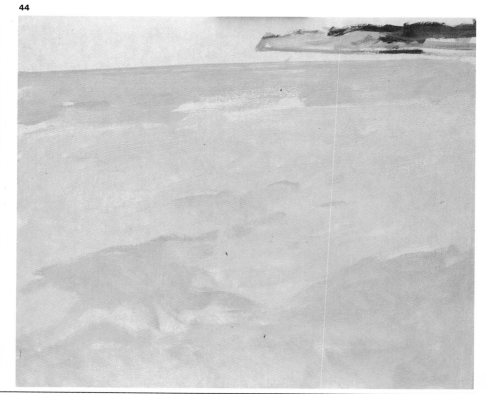

Second stage: the sky and the sea

Using a new paintbrush, in this case a flat one, Via goes to work on the sky, naturally using a sky blue.

This sky blue is made with an abundant amount of white mixed with ultramarine blue and a slight dash of light yellow ochre and another dash of vermilion. As decidedly as ever, Via applies the mix to the sky. Adding a little more vermilion to the mix, he achieves a somewhat more violet tonality than the previous blue.

Now Via introduces an almost pure white impasto (a cloud), which with a little gray is practically finished. And again he changes his brush.

Then Via mixes a medium brown similar to the one in the lower area of the beach, and works on the strip of land that leads out to the sea. He adds different colors to the mix until he gets a dark grayish green.

The weather is changing; the sun is going in and out. But the painter has already decided on the color theme; he is not going to change it to suit the varying meteorological conditions.

By adding a little green and vermilion to the white and blue, he produces a tone somewhat akin to cyan—a pastel blue, very close to Prussian blue lightened up with white. With this color, he fills up the area that will be the sea. Via takes another brush, a finer one, and fills in the cove part of the sea, between the beach and the mountain.

Now he subtly increases the amount of green on the right with the blue tendency he has on the left.

As you can see, the painter has created, almost instinctively, an area with a determined color that is influenced by its nearest color. As a result of this, the area of sea situated under the green of the mountain is greener than the sea area that has the light blue of the sky over it.

At the end of this stage, you could say that the four essential elements of the composition—sky, mountain, sea, and sand—have been defined.

Figs. 45 to 47. Now, Via will work on the sea and sky. As you know, the sea and sky are not one color... they have many colors. It is the light, or the artist's interpretation of this light that determines the atmosphere and general tonality of the painting. The artist must also take into account the reflection of the sky into the sea. Via's seascape is luminous. He is painting on a partly cloudy, but clear day, with odd clouds floating about. For this reason, he paints the sky blue... later incorporating green and vermilion to the color to paint the stretch of sea.

45

46

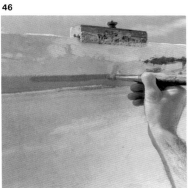

47

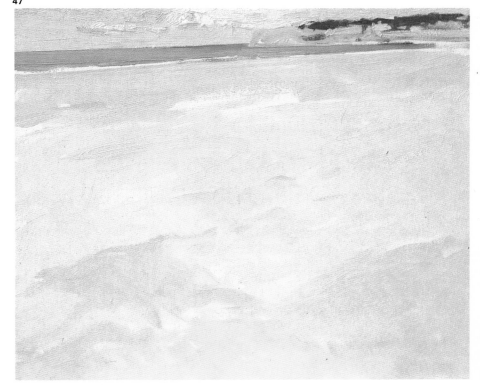

Third stage: working on the details

The painter rests a little and contemplates his work. He notices that the sea is a little twisted or inclined: "It falls off to the left. This doesn't usually happen. Maybe the easel is slightly tilted."

Via immediately begins to correct the sea, making it horizontal, just as he likes it: "There are many pictures by famous painters in which you see things leaning one way or the other; they didn't seem to give it much importance. I do give it importance."

Having corrected the sea, Via goes back to work on the upper area of the beach. Using a tone with more white than the previous tone applied, he makes the area slightly lighter. With a thick round brush, the arstist generously covers the canvas with impastos: "I use a lot of paint, especially white. In some of my paintings I have used six or seven tubes of white, and in a normal picture you might use only two tubes of white."

Using basically green and yellow ochre, Via produces a broken green mixture. He stains this green along the upper beach area. Then he immediately modifies the area by dirtying it, and very decisively, he introduces green patches in the central area of the beach.

For the first time since he started this painting, Via takes up two fine brushes, nos. 6 and 8, and proceeds to introduce small details in the background. He uses an almost pure ultramarine blue, a vermilion which he partially rubs out with another brush, and a mauve tone for fine vertical and horizontal lines. All of the small details in the background—the boats, the abandoned refreshment stand, the small concrete building—add a human presence to the seascape.

In painting very concrete details, Via doesn't use his usual impasto technique; instead he dilutes the paint with a little turpentine. For the moment, the carmine on his palette has remained untouched.

48

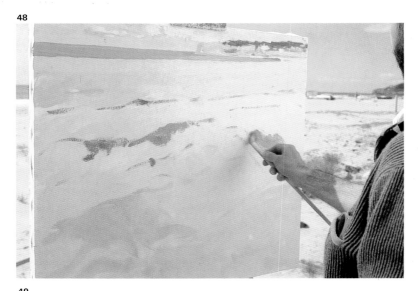

49

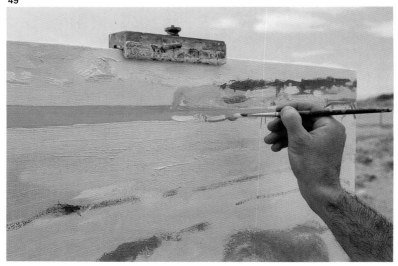

Fig. 48. Via returns to the main focus of his painting: the sand. He stains the central area with energy and precision, using loose green brushstrokes. At this point, he is not distributing the green tones exactly where the weeds and grass are located, he is suggesting them and adding a tonal equilibrium to the large sand area of his composition.

Figs. 49 to 51. Now, Via changes brushes. With a very fine round brush, which he alternates with other brushes of the same size so he doesn't need to clean them right away, he starts on the details in the upper part of the painting. Notice how he has varied his way of holding his brushes. In fig. 48, where he is painting the areas that suggest the weeds, he

holds the brush in a way which allows him to paint with a straight arm; while for the small details, he holds the brush like a pencil in order to paint close to the painting.

With great precision, Via uses three brushes to construct the small building: a light gray in the left part, a sharp white in the right, and a brownish line for the roof.

The painter constantly looks at the motif and then applies his brushstrokes. His glances do not seem to produce any pause for reflection.

Now, he mixes a very light green, "very transparent," he says, for application on one of the boats. The elements separating the sea from the land (fundamentally the boats) are finished. Through the small details of the boats, a more varied coloring is now introduced into the painting.

"When you look at your painting in the studio," the painter says, "after having painted it outside, the artificial light will usually favor the colors that you produced from nature's own light."

50
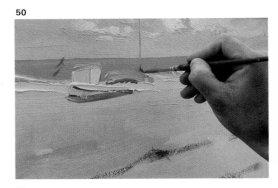

51

52
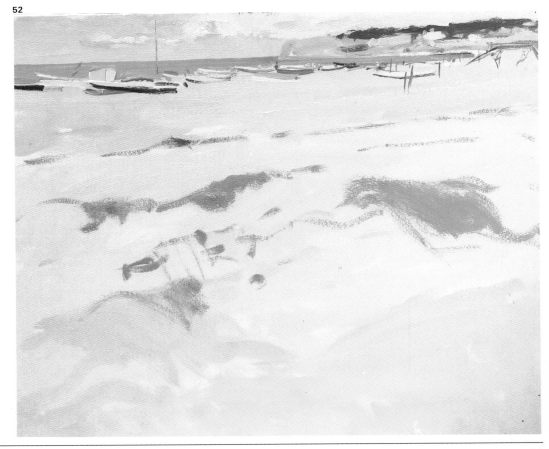

Fig. 52. The painting in this stage is not only nature—sea, sand, and the strip of land—because Via has included boats and a few constructions along the shore line, which divides the beach from the sea. Take note of the importance in the color distribution in the top beach area of the picture: a blue, an almost pure ultramarine blue, for the biggest boat, and dispersed green brushstrokes. These cool colors harmonize well with the colors of the sky and the sea; they help to distance this area from the predominantly warm center plane and foreground.

Fourth stage: the sand again

After cleaning his hands with a towel Via carefully observes the scene and continues to advance the painting. Using a dark ultramarine blue for the chairs stacked in front of the refreshment stand, he creates a blue patch in the upper right-hand corner.

Via completes the identifiable references according to the way he wants them done. In the upper beach area, you can see that the identifiable objects constitute an irregular line of different colors. Now, the painter will begin what he qualifies as the most interesting phase of this painting: the resolution of the sand, which occupies most of the canvas.

He cleans the container that had the turpentine in it. Then, from an already opened tube of white, he squeezes all the paint onto the palette. But even this is not enough; he gets another tube of white and adds more to the palette. Then, he picks up one of his thick brushes.

"There are painters who paint the whole picture at the same time. I don't. I generally start at the top, and when it's finished I go down and attack the bottom part."

In this aspect, Via works in the classical tradition of beginning with the horizon line and working toward the foreground. "That way," he says, "it's easier to give the painting depth rather than doing everything at the same time. If you start at the most distant part and work toward the nearest part, you'll obtain better relief, and you'll be able to play with different tones and intensities at the same time."

In the center of Via's palette, there is an enormous white blob shaded by various tonalities, like brickwork. With this palette, he works the sand area, applying thick impastos.

He partially covers an area of green that he had painted in the previous stage, and then he elaborates on another green area by redoing patches with greens. As a result, there are a variety of broken greens: warm and dark sienna-type tones, and warm and dark grays.

"Now," Via announces, "is the most difficult moment, when I must know where to apply every brushstroke, because if I do it badly I'll ruin the whole painting."

Fig. 53. Via usually uses very thick brushes, which surpass the normal brushes used in oil painting. Using a lot of white, he covers some of the green shrubs in the central part of the beach.

Fig. 54. Next, he mixes different tones of green to lighten and darken the isolated patches of vegetation, which up to this point were a uniform green.

53

54

55

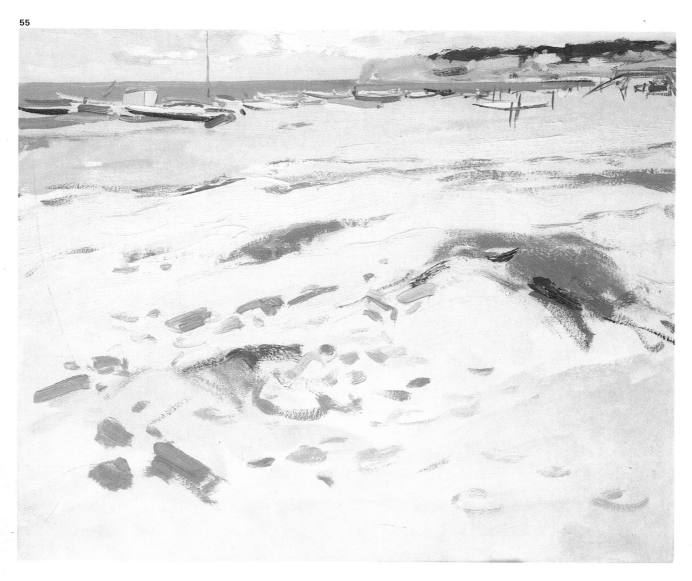

Fig. 55. In this present stage of Pere Lluís Via's seascape, the variety of visual references and tones that have been introduced are outstandingly clear. Via is not a precise detail painter; his work is governed by creativity. On the other hand, the painter likes to find challenges. There have been some occasions where he has painted great expanses of sand without including any other elements, only sand in a great variety of shades. In this particular seascape, Via has introduced visual references: pieces of bricks, with which he has established a foreground in the lower left-hand side of the picture, and other dispersed forms in the sand. All help to break up the uniformity of the beach. Via's way of working is worth a mention. He loads his brush with a lot of color and uses wide strokes with great confidence. At this stage of the seascape, he has done very little with the top part of the picture. There are a few seats piled up in front of the refreshment stand, in the right-hand corner, which he painted with a dark ultramarine blue. Working mostly on the sand, he has painted the bricks and darkened the green patches. He has also used a lot of white in the central part of the beach, which from the start was lighter. He still has the sand area marked off into three areas: two dark ones, one near the sea, the other in the foreground, and a light area in the center.

Fifth and final stage: decisive touch-ups

Via mixes yellow to an abundant amount of white and with one of his thick brushes, and applies the color onto the lower half of the sand. Changing brushes, he goes back to the middle sand area of the beach. This time he partially covers the green on the right. He produces warm and earthy tonalities.

He uses predominantly thick brushes but every now and then he uses a thin one to paint the vertical tendency of the grass with a kind of light viridian. For the first time since he started the painting, he adds carmine, using it to stain areas that will represent the pieces of brick on the center left part of the beach.

Next, he produces a grayish mixture and goes back to the upper part of the painting. He paints in what will be the narrow vertical cement cylinder with one brushstroke, adds some white touches to the hill, and defines the houses. A dab of almost pure vermilion suggests the presence of a person on the beach.

The painter allows himself a long pause for the first time and contemplates his work thoughtfully.

Using a thin brush and a considerable amount of lemon yellow he applies some touches on the ochre green area on the right side of the canvas, suggesting the yellow flowers in the grass. He keeps working on light modifications: a darker gray on the left side of the cement mass, and more blue to the sky. He adds more white to his palette in order to partly redo the clouds, providing relief with gray.

The painter has spent scarcely two hours on the painting, from eleven in the morning to one in the afternoon. There is only the signature left. He signs the painting with a thin brush while the sun shines fiercely and the wind gets worse.

Looking at the palette, I can see that the lemon yellow has scarcely been used, and the carmine is barely touched. The painting has changed considerably during the session, but in some areas the initial stains can still be seen.

"When the first application seems acceptable to me, as in this case, I let it breathe somewhere in the final state of the painting."

Fig. 56. Via now goes back to the part that he has ignored for so long: the sky. He applies more blue in order to give it more luminosity; then he gives form to the clouds, individualizing them at the same time. Via rectifies the cloud relief with gray and then goes on to add a light pink tendency.

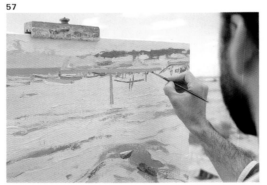

Fig. 57. Improvising, Via adds an unexpected element to his seascape. In the background, near the boats and refreshment stand, he suggests the presence of a person on the beach with vermilion, using a very fine brush, something this artist rarely uses.

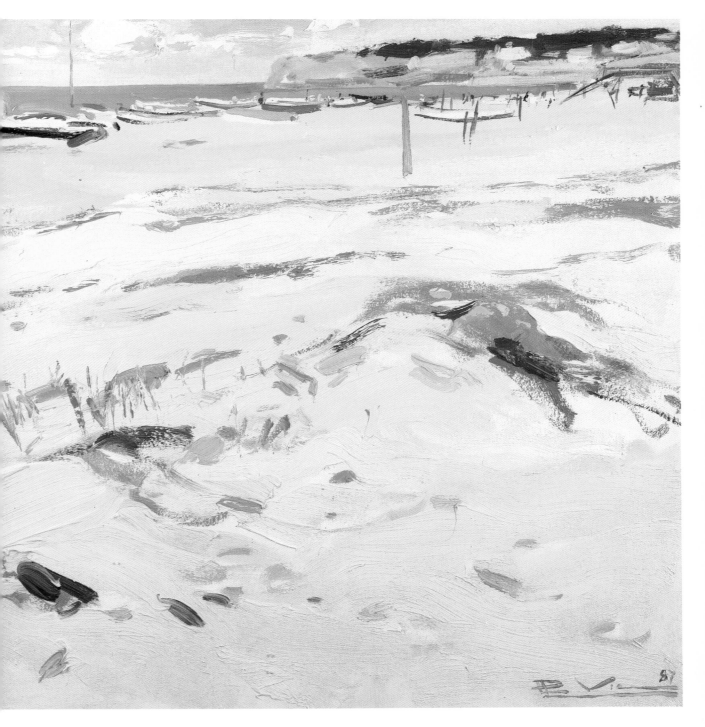

Fig. 58. This is the finished version of Via's seascape. All the touching up he has carried out in this last stage has lead to one fundamental goal: to accentuate the quality of the picture. He applied carmine to the bricks, shaded the central white area of the beach, and incorporated one new element: lemon yellow patches over the ochre-green area. The finished work is a creative resolution of a beach scene with numerous forms in it. Via's seascape constitutes an excellent exercise in composition.

A teacher of painting and drawing

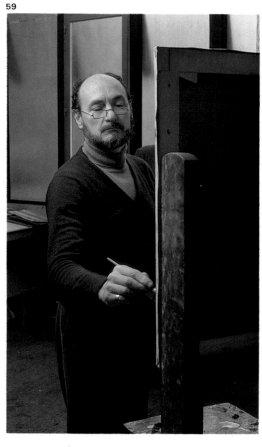

Pascual Bueno was born in Barcelona in 1930. From the Faculty of Fine Arts in Barcelona, he obtained his diploma as a teacher of painting and drawing.

He is a painter of international prestige with works in museums in Florence; New York; Oakland, California; and Montevideo. His exhibitions have mainly been in Spain and the United States. He obtained many prizes prior to 1973. At that point, after achieving first prize in the Spanish Sports Federation competition, he decided not to take part in any other competitions.

Pascual Bueno's studio is very large: 26 ¼′ (8 m) wide, 55 ¾′ (17 m) long, and 16 ½′ (5 m) high. It features a raised section, 13′ × 26¼′ (4 × 8 m), and a large window that provides a northwest light, which passes through transparent glass in the upper part and translucent glass in the lower part. It is a custom-made studio, built by masons who followed the painter's instructions. Bueno not only paints but also gives private classes there.

"I'm a very bohemian person, but also very much in control."

Fig. 59. Pascual Bueno is fundamentally a landscape and seascape painter, both rural and urban. He favors painting outdoors, but as an exception to this rule, Bueno is going to paint this seascape in his studio, from an oil sketch painted a few months ago.

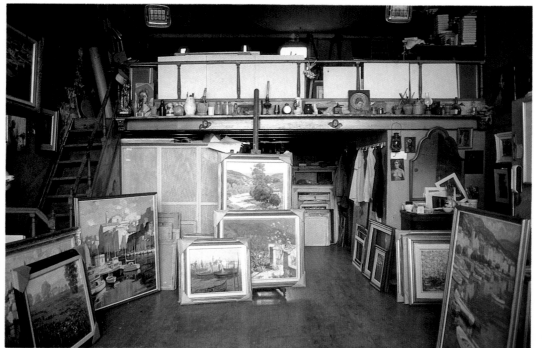

Fig. 60. In Bueno's studio, which takes up the entire upper floor of a building, there is ample space. Space to paint, to store paintings, and to give private painting classes. Although it does not appear in this photograph, Bueno's studio has a large window with transparent glass in the upper part; this provides him with zenithal lighting, the best type of lighting for studio painting.

Seascapes and landscapes by Pascual Bueno

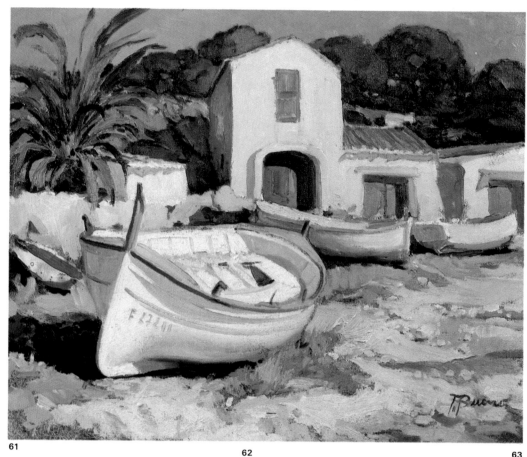

Figs. 61 to 63. Although the seascape painted for this step-by-step process was painted in the studio, Pascual Bueno prefers to paint outdoors. For it is when faced with the actual motif that the landscape and seascape painter can really see and interpret the light and the atmosphere of the motif. Working in different lights and atmospheres provides inspiration for creativity and allows the painter to approach each painting—even the same motif at different times of day—as an exercise in broadening his knowledge of light and color.

61

62

63

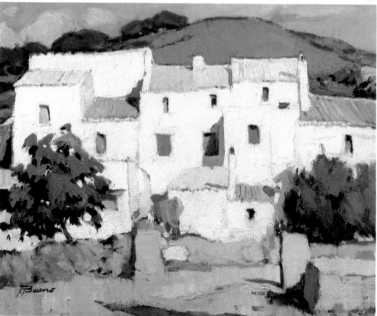

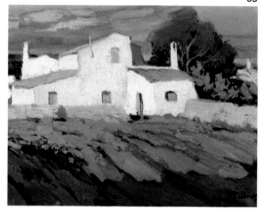

Painting a seascape in a figure format

Formats

Since Bueno is going to paint a seascape in a vertical format, not as frequently used as the horizontal format, it seems appropriate to discuss the various formats. Why is one picture painted in a large format and another in a small one? Why paint in a figure format, a landscape format, or a seascape format? Why a vertical or horizontal format?

"Both the size," says Bueno, "and the format and layout of the canvas are decided by the motif. With the motif before him, the painter must decide whether to place the canvas vertically or horizontally. As far as the size is concerned, for sketches, a small canvas is more suitable for achieving synthesis. As for painting a seascape on a seascape format, or a figure on a figure format, I disregard this. I made the sketch on a no. 8 figure format, and I am now going to paint on a no. 12 figure format. It is the motif that determines the format: vertical, not too large, figure format."

N°	figure	landscape	seascape
	INTERNATIONAL FRAME MEASUREMENTS (in centimeters)		
1	22 × 16	22 × 14	22 × 12
2	22 × 19	24 × 16	24 × 14
3	27 × 22	27 × 19	27 × 16
4	33 × 24	33 × 22	33 × 19
5	35 × 27	35 × 24	35 × 22
6	41 × 33	41 × 27	41 × 24
8	46 × 38	46 × 33	46 × 27
10	55 × 46	55 × 38	55 × 33
12	61 × 50	61 × 46	61 × 38
15	65 × 54	65 × 50	65 × 46
20	73 × 60	73 × 54	73 × 50
25	81 × 65	81 × 60	81 × 54
30	92 × 73	92 × 65	92 × 60
40	100 × 81	100 × 73	100 × 65
50	116 × 69	116 × 81	116 × 73
60	130 × 97	130 × 89	130 × 81
80	146 × 114	146 × 97	146 × 90
100	162 × 130	162 × 114	162 × 97
120	195 × 130	195 × 114	195 × 97

Fig. 64. Pascual Bueno, as do many other artists, disregards the international frame measurements table. He will paint a step-by-step seascape in a figure format. In the photograph below, you can see the unusual formats he uses.

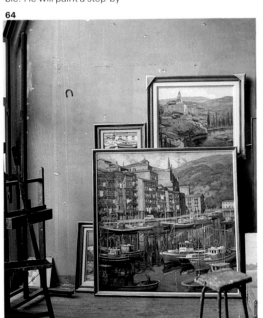

65

66

67

Figs. 65 to 67. In France in the beginning of the nineteenth century, prepared canvases in standard measurements were being sold, but they were not yet differentiated according to motif. It was around 1830 that the wider format appeared for landscapes and an even more oblong format for seascapes. The table reproduced here has been used by frame manufacturers practically without any changes for approximately 150 years. The examples on this page show the proportions for each format: figure (F), landscape (L), and seascape (S). The figure format is the most square, and the seascape format is the most oblong.

Starting with a neutral background

In the studio or outdoors

Although he is going to execute this painting in his spacious studio, Bueno states that he prefers to paint landscapes and seascapes outdoors, with the motif in front of him and not following a preliminary sketch.

"I always tell my pupils to paint from life, outdoors, facing the motif."

"In the studio, the painter paints what he knows how to. Outside, with the motif before him, he also paints what nature makes him feel, what the motif suggests to him at each moment."

On many occasions, the painter is astounded by what he can paint face-to-face with the motif, because it comes unexpectedly and is not planned. In such a case, the subconscious begins to work. However, the painter must channel his subconscious, or inspiration, in the most suitable direction.

"For the landscape artist, the most important thing is to adapt the natural light to his needs and not to adjust his needs to the motif."

Painting must not become a mechanically repeated exercise. Each painting should be approached as a new problem to be solved.

Opening his arms and pointing around his large studio overflowing with paintings, Bueno exclaims without false modesty:

"Here, there are fifty paintings and fifty different skies and atmospheres. The painter who always works in the studio will always paint the grass, the ships, and the houses in the same way. He becomes used to treating his subjects in an identical fashion."

Each painting is individual, a separate entity that the painter must work on in a specific way. This is the criterion that has always guided Pascual Bueno.

"The greatest lesson from Picasso, my most admired artist," Bueno continues, "was that as soon as a movement such as cubism was discovered, he began to search for another, to explore a different area, rather than continue exploiting what he had discovered and experimented with."

Staining the canvas

Just as Vermeer or Mondrian would have done, Bueno places his enormous easel in such a way that the light from the large window comes from the left. As you will notice, the canvas is not "clean" (fig. 68). Bueno has stained it with a highly diluted coat of a neutral color.

"It is better to begin in this way rather than with white. With this neutral background, you can better evaluate the lighter and darker shades, and you can appreciate the composition, harmony, and contrast better."

There is no chair or stool; Bueno stands while he works. He says it is noticeable if a picture is painted while standing up; the painter's movements are reflected in the painting: "The painting of an artist who sits while he is working is more static."

Fig. 68. When asked whether it is better to begin painting on a white canvas or a canvas with a colored background, Bueno prefers the latter. In this way, he is able to better appreciate the painting from the beginning.

The palette and the sketch

As you can see, Bueno's palette is rectangular with a hole to hold it, and there is a tin container for the turpentine. This is the layout of the colors, from left to right:

> ultramarine blue
> azure blue
> sap green
> light green
> dark green
> turquoise green (a mixture)
> cadmium yellow
> yellow
> orange
> scarlet
> red
> alizarin crimson
> violet
> ochre
> terra rosa
> burnt sienna
> black

Many painters do without black, but Bueno justifies its presence on his large palette by referring to Renoir, who said that black was not a color to fear, that it was no more dangerous than white. "The point is," adds Bueno, "that you must know how to use it. Not for the dark shades but rather for the lighter ones. For example, black is extremely useful for obtaining a flesh color. Or for the sky.

"It should not be thought," Bueno continues, "that black is for darkening and white for lightening. Colors are darkened or lightened by mixing them together, not by adding more black or white."

Fig. 69. Black, a color that many painters shun, appears on Pascual Bueno's palette. Bueno feels black is as valid a color as any other, provided you know how to use it. Avoid using black for creating darker shades; instead, try mixing other colors, especially blue.

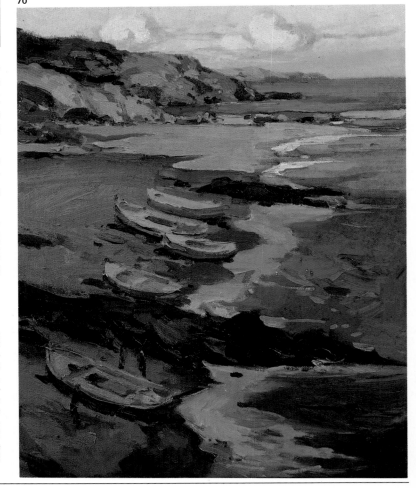

Fig. 70. As you can see, the oil sketch Bueno will use for painting the seascape in the studio is almost a finished painting. The seascape which Bueno is going to paint step by step will not vary greatly from this sketch, although the slight differences will be significant (compare this sketch with the final seascape on page 39).

First stage: abstract art

Bueno begins by staining the canvas with a yellow mixed with orange. His brushstrokes are resolute and wide (he uses a flat no. 20 bristle brush), covering large areas of the canvas. He mixes white with violet to get a kind of mauve tone: "One must not become a prisoner of the drawing, so begin to paint right away. There will be ample time for drawing while you paint." As Titian said, paint from the beginning.

The painter glances at the oil sketch occasionally, but does not overly concern himself with it; he stains the canvas firmly. He begins to work on the sea with blues and greens. Ultramarine blue, white, and sap green are the main colors involved. Sometimes he squeezes a color directly onto the paintbrush.

"The important thing," he says, "is to stain the picture from the beginning with broad tone: cool and warm colors, strong and weak values, and not to go into the details of the painting." Quite the opposite of other painters who begin by drawing very carefully.

What you see now is an abstract painting in which the important thing is the relationship between the colors. Little by little, this nonfigurative painting will become a seascape similar to the sketch—although it is relative when I say little by little, because Bueno paints extraordinarily quickly.

"The painter must capture the essence, the first thing his retina records, right from the first moment," states Bueno. Does that remind you of anything? Of course, the great impressionists.

Fig. 71 and 72. Bueno's painting is characterized by the extraordinary speed at which he fills the canvas with color. The artist does not consider the old dilemma of which should come first, the painting or the drawing. Without hesitating, he paints rapidly, covering the largest areas of the surface with color.

Fig. 73. On studying this first stage of Bueno's seascape, one immediately reaches a conclusion: His rapid and firm way of painting comes from the confidence he receives from having drawn up a prior plan. He has evaluated the tone of the main areas in a way which will help him harmonize the overall painting.

71

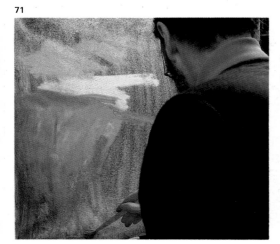

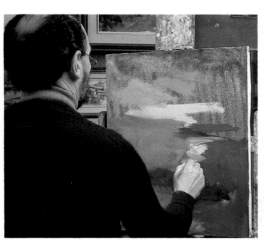

73

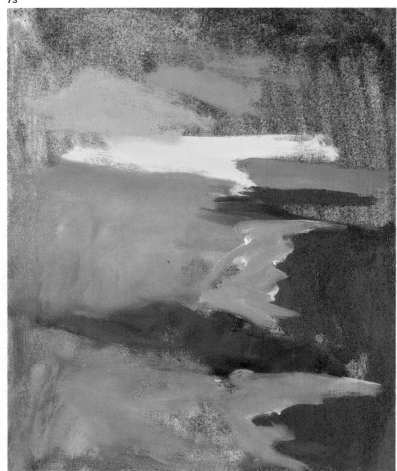

Second stage: reality begins to appear

With the same firmness used for staining the lower part of the painting, Bueno begins on the sky: a lot of white, and yellow and green.

Sienna and a subtle green are used for the headland, or cliff, which meets the sea in the upper half of the painting.

He is still in the domain of an abstract painting, a pure relationship between shape and color, but already certain elements of reality begin to appear.

The initial neutral staining of the background of the canvas is quickly disappearing.

Perhaps if you did not know that this is a coastal scene (the island of Minorca to be exact, where Bueno made the sketch three months earlier), you would find it difficult to determine what the shapes refer to. But since you do know, you may begin to recognize certain elements: the sea, the beach, the headland. You may even guess, or already know, that the light shapes on the sand will be the boats.

"You cannot begin a painting by finishing it," says the artist; "you must look on it as a problem to be solved, which is solved as you paint." It is not a case of drawing a plan like an architect and then building like a bricklayer, but rather of drawing and building at the same time. Bueno uses a lot of paint: He introduces fresh paint, squeezing the tubes as the colors on his palette run out.

Up to now, Bueno has been alternating between three brushes—painting very quickly. He usually works with a wide brush and two flat bristle paintbrushes, nos. 18 and 20. Occasionally he will rapidly dip his brush in turpentine to clean it, and dry it with a rag on his left.

Bueno's movements are nervous and energetic, whether he is spreading color over the canvas, dipping the brush in turpentine and drying it with a rag, or outlining a form with a fine round brush.

He never hesitates.

74
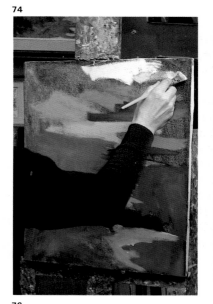

75
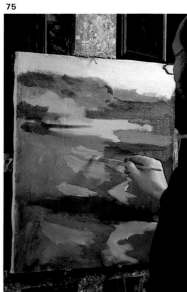

76
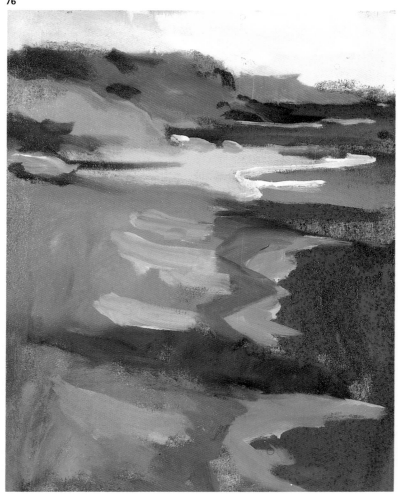

Third stage: the shapes are defined

As you can see, the shapes are now becoming defined. The rocks at the edge of the water are now clearly visible, as are the foam of the waves and the different colored water.

"The painting must be stained immediately, as soon as possible, in order to obtain a good tone. When you have stained the whole picture, then you can really start painting, because if you try to obtain a color contrast from a white or blank canvas, you will never find the relationship between one tone and the other. It is only after you fill the canvas with the basic tones that will make up the painting that you can start to work."

77

Figs. 77 to 79. With his method of painting, Bueno has covered the initial neutral background color with very thick layers of paint. He emphasizes the harmony of the warm colors and uses a lot of white for the clouds and the sea. With three brushstrokes, he suggests three human figures on the beach next to the boat in the foreground.

78

79

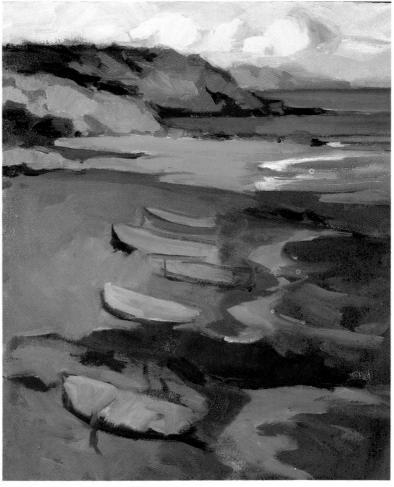

Figs. 74 to 76. With a wide bristle brush, Bueno paints on thick layers of color in the sky, the cliff along the water, and the boats. Notice that in the previous stage (fig. 73, p. 33) where Bueno covered large areas of the picture with color, he was in fact creating three tonal areas of the beach, which at this stage (fig. 76), have been defined, giving different degrees of luminosity to the sand. At the same time, the cliff in the upper third of the picture and the sea have become "real," distinguishable elements. In the previous stage Bueno had also introduced different tonal gradations for the sea.

Fourth stage: increasing the tone

You now see a figurative picture. The sea is now the sea, the waves are waves, and the rocks are rocks.

Nevertheless, the tonality, the relationship between the colors as discussed by Bueno, is still there. Not only is it still there, but the figurative progress of the painting is improving the color relationship—giving true value to the different relationships of tones that before were mere stains on the canvas.

Pascual Bueno continues to add color, squeezing the tube when needed.

He paints various areas all at the same time; he works on the clouds, then the waves, the boats, the sea, and the rocks, all at the same time, darting from one part of the painting to another. He uses a lot of white and some green as well as warm tones to obtain the colored cloud effect. He continues to work with thick, pure color.

"I may have done the sketch in half an hour," he says, "but what people often forget is that there are forty years of painting behind that half hour."

Bueno is now working on the upper third of the painting—the sky and the rocks—with the same energy but with more care. On some occasions, he rectifies small details with his fingers. Pure white is used for the waves breaking into foam in the upper part.

As you can see, the upper third of the painting is fairly detailed. Observe how the clouds and the rocks of different shades are all within the warm color range. Everything is tinged stroke by stroke, even though they are fairly broad strokes.

Also notice the area of direct sunlight on the nearest rock, the ochre sand, and the turquoise water. See how this sunlit area contrasts with the rest of the painting that is in shadow: darker rocks, ultramarine seawater, and mauve sand.

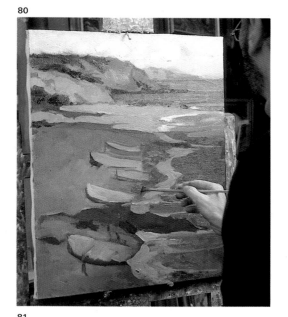

80

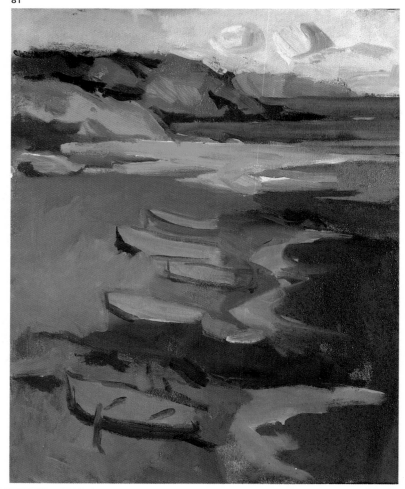

81

Figs. 80 and 81. Now, Bueno defines the boundaries of the beach by darkening the mallows in the sand. Without losing the color harmony that he established with the initial large color stains, Bueno advances toward reality by accentuating the tonalities.

Fifth stage: drawing while painting

Now, Bueno works on the middle area with extra care.

He uses a great deal of ultramarine blue, but he also uses other colors: It is not a question of filling an entire area with the same color, in this case ultramarine blue. He mixes ultramarine blue with green, and uses white as well.

Although at this stage he mainly uses the flat brushes, nos. 18 and 20, the artist also occasionally uses a round no. 5 brush, with which he stains the area surrounding the boats. The boats are now "empty spaces"

surrounded by sand, which is gaining its definitive character.

The painter insists on mauve for the shadowy parts of the sand. The mauve subtly changes the color of the area, enriching it with a series of tonalities and thus avoiding a uniform expanse of color. Bueno retouches here and there, going over painted areas.

The drawing which Pascual Bueno said would appear little by little in his painting is now present. If you look at this rapid, energetic painting-drawing carefully, you will see that only the boats need to be completed.

Figs. 82 to 84. The artist darkens the rocks in the central part of the beach. By doing so, he breaks up the evenness of the color of the sand. Bueno works on the right third of the painting with ultramarine blue, occasionally mixed with green and white. At this stage, both this section and the upper section are finished. A gradation of light and shadow was achieved by using different color intensities—an appropriate method for a colorist painter.

82

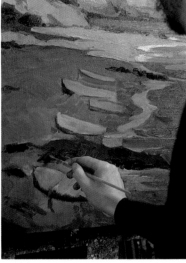

83

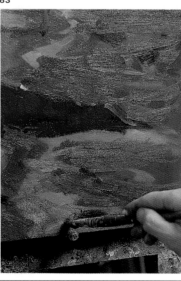

84

Sixth and final stage: the boats and the illusion of depth

The fingers are used more in this stage in order to trace the details. Bueno will round off his painting by working on the boats that are drawn up onto the beach.

Compare the differences between the sketch and this rapid painting, completed in an hour and a half. Bueno wanted to work on the painting in the same style as the oil sketch, without losing the spontaneity.

Observe the slightly different treatment given to the sky and the clouds. Notice how the rocks have been simplified, stroke by stroke, and give greater strength to the upper part of the painting. The foam on the waves recedes with greater accuracy; and the shadowed area of the sand, the mauve area, now has a greater variety of hues, making it less uniform.

But perhaps the most noticeable difference can be found in the boats. In the sketch, they were almost all the same color, similar to the mauve color of the sand, thus offering little contrast. In this picture, however, the boats have been painted in three different tonalities: the one furthest away in blue, the second in light mauve, the third in whitish gray, the fourth in light mauve, and the one in the foreground in ivory and pearl gray.

In this final painting, the painter has achieved two goals. First, he has created greater contrast between the boats and the sand; the boats now stand out more. The contrast adds life and movement to the entire painting. Second, the boats have been individualized, establishing a perspective of distance that increases the sensation of relief and depth. Notice how the first boat is the most contrasted and the most detailed of the five boats. It therefore becomes the foreground of this seascape (the three figures around the boat are also painted with livelier colors than those in the sketch).

"A painter needs someone to stop him," exclaims Bueno. The journalist and the photographer decide to end the session.

85

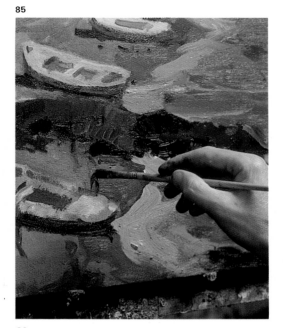

86

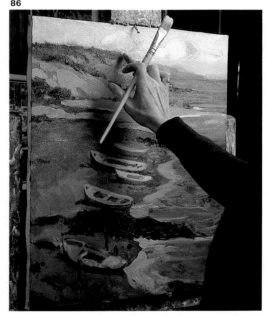

Fig. 85. With several brushstrokes of a warm color, Bueno paints human figures around the boat in the foreground to make them stand out from the dark color of the beach. These figures also provide a center of interest for the foreground of the painting.

Fig. 86. One can also paint with his fingers. Bueno uses his fingers to extend and lighten the color of the cliffs, a part of the painting full of light. He leaves out the details of the cliff that are in the original sketch.

Fig. 87. Bueno believes painting outdoor scenes in the studio may be more cerebral and mechanical, but it is no less creative. Compare the oil sketch that the artist has used as a model (fig. 70, p. 32) with the finished seascape. There are subtle but important differences which affect the expressive strength of the painting. There are slight variations in the language used by the painter to communicate. First, Bueno has treated the cliffs differently: He has worked less on the rocks and has painted lighter shaded areas, lending more strength and color to the painting, which is already an explosion of color. Second, the boats in the oil sketch were not individualized; they were painted in the same color, very similar to the sand. In this seascape that Bueno has just painted, the artist has defined each boat more fully—emphasizing the different planes and thereby producing sensations of depth.

87

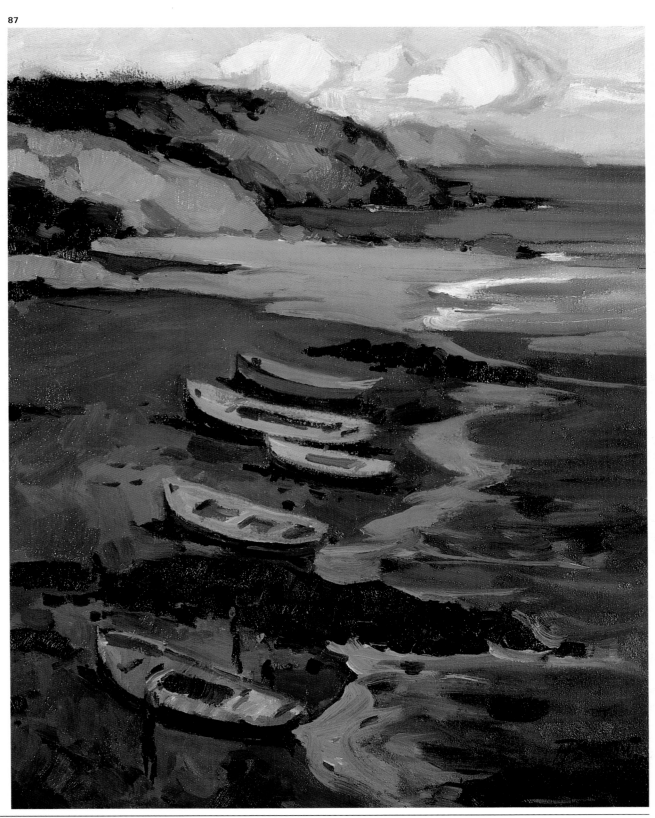

Selecting the subject

Josep Sarquella was born in 1928; and although he was raised in an inland town in the province of Barcelona, he has specialized in seascapes. Most of his paintings are of the port of Palamos, a town on the Costa Brava, which has awarded him with a gold medal. He was also awarded a gold medal in Paris by "Les amis de Montmartre." In the international gallery Val d'Or, in France, he won the first prize for seascapes. In 1979, he received first prize in the Bourgogne Franche-Comté Award for painting. He has exhibited his paintings in France, Spain, England, and Holland.

With Sarquella, you are going to paint a seascape outdoors, in the port of a large city. Not in the commercial area of the port, but in the yacht club, where different-size leisure yachts are anchored.

"I prefer to paint here because it is the area I know best," says the painter as he begins to set up his easel. He brought the easel in his car, which he has parked nearby. Sarquella carries out all his preliminary tasks with cigarette in mouth.

There are two decisions a painter must make before starting to paint: what to paint and from what angle. Sarquella may paint the motif to his left (fig. 90), the one facing him (fig. 91), or the one seen to his right (fig. 89).

Sarquella decides on the last motif, but places the easel in such a way that the subject is to his left. In this position, the easel is in the shade: "I don't like the sun shining directly onto the canvas because it dazzles me and changes the colors."

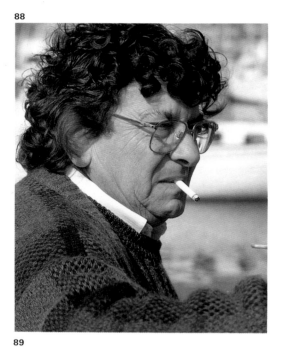

Fig. 88. Josep Sarquella specializes in seascapes. He usually sets up his easel on a beach, but for this session he is going to paint a small part of the yacht club in the port of Barcelona.

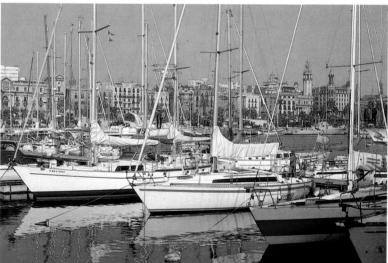

Figs. 89 to 91. The choice of subject is fundamental when painting outdoors because new elements are introduced that the artist has no control over, but which he must capture and interpret. Sarquella finally chooses the motif which appears in fig. 89. Compare this photograph with the finished Sarquella seascape (fig. 116, p. 51) in order to appreciate his interpretation and synthesis.

Sarquella's work

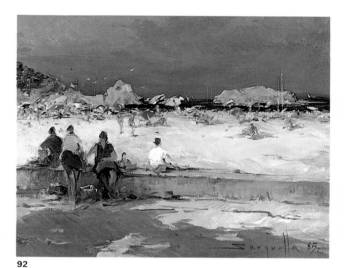

92

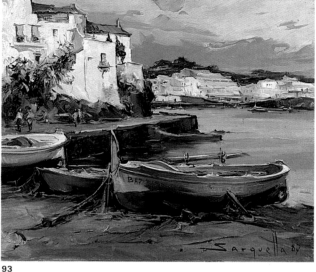

93

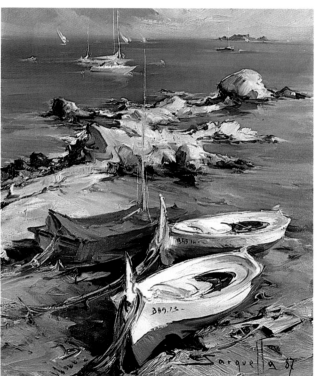

94

95

Figs. 92 to 95. The secret of painting well is to construct, to model shapes, and to disregard the "outer shell" of the motif and to imagine the "internal structure," the basic shapes. In order to draw directly with a brush or make a preliminary sketch, you should have a good knowledge of constructing shapes—remember, all shapes have a geometric structure, as Cézanne once said. A command of perspective is also important, because every shape in nature is subject to this important visual law. In Sarquella's work which appears on this page, the artist reveals his wide range of knowledge in drawing and perspective such as the compositions of the boats in figs. 93 and 94. He also uses other artistic resources that every landscape and seascape painter must know about to create a sensation of depth, or an illusion of the third dimension. For example, in fig. 92, Sarquella creates depth with planes that are successively superimposed.

The palette and the first stage

Sarquella's palette is covered with paint. "Since I'm always painting, that's how I keep it."

Here are the colors, listed from left to right:

> gold ochre
> burnt sienna
> carmine
> emerald green
> light green
> dark cadmium yellow
> light cadmium red
> light cadmium yellow
> cobalt violet
> light ultramarine blue
> raw umber
> white

Once the subject and the angle of vision have been established, the artist selects very clean, flat bristle brushes: nos. 10 and 12. He creates a mixture, diluted with turpentine, with yellow, white, a little blue, and quite a lot of violet.

With a fine, rounded no. 5 brush, Sarquella finely outlines a sketch of the boat. Then the vertical lines of the reflections and the masts begin to appear. He says that the turpentine which he has in the two oil bottles on his palette is only used in this stage for outlining. But, now and then, he uses some impasto.

The small yachts have been introduced with fine outlines, as if sketched with pencil. Sarquella now sketches in the shapes of the buildings in the background with highly diluted shades of color.

Up to now, he has used a lot of violet and yellow, which, as you are aware, are complementary colors. But, he has also used all the other colors on his palette in small diluted quantities.

As you can see, Sarquella has used the canvas in its original state, seeking color harmonization directly upon the white ground.

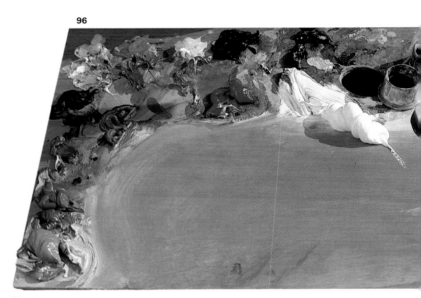

96

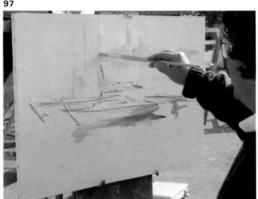

97

Fig. 96. Sarquella's palette abounds with white, which he uses judiciously to make mixtures.

98

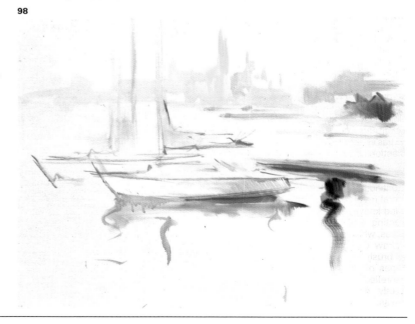

Second stage: reflections in murky water

Although it is an early stage, the painting is in synthesis. Every major element of this seascape has already been sketched: the leisure craft, the main protagonist of the picture; the reflections in the water; the bank; the buildings in the background.

Naturally, the painter does not have to record the total reality—the photograph is the truth, as Jean-Luc Godard used to say. Compare the photograph of the motif (fig. 89, p. 40) with Sarquella's painting in this early stage. You will notice that the artist has carried out what certain artists call purification.

For the moment, the artist is working on only two boats. He will ignore the boats that he feels are of no use for his composition. Sarquella paints with firm brushstrokes, which have quite a lot of paint. He occasionally flattens the brushmarks with a palette knife.

Sarquella's drawing-painting contains a great deal of energy. Notice the quick, stretched-out horizontal brushstroke; it is

a steady, unhurried line. With quick movements, he paints wavy lines to sketch in the reflections in the water.

Sarquella uses a no. 24 brush to work on quite a lot of the central motif. At the end of this second phase, he has established noticeable relief. Both boats are fairly "full" of color, as are their reflections in the water, while the rest of the painting remains as it did after the first stage.

99

100

Figs. 97 and 98. The first thing you see on Sarquella's canvas is a drawing; a drawing broadly sketched with a fine brush, with which the boats and the vertical lines of the masts are outlined. Sarquella has begun drawing on the white of the canvas without any prior preparation. Using a little more color, he has started on the background of buildings and has introduced the first reflections in the water.

Figs. 99 and 100. Sarquella continues "drawing" his central motif, proof of his sound knowledge of constructing and laying out shapes, which enables him to draw confidently with the brush. He fills in the shapes of the boats and their reflections with color, directly onto the white canvas.

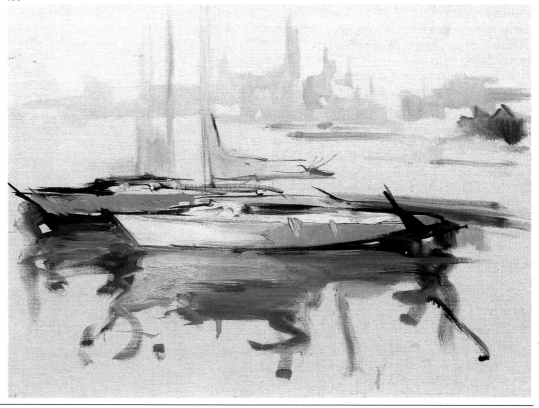

Third stage: expansion

You may have noticed that this seascape is not in the classical seascape format: It is, in fact, a no. 20 figure format 28 ¾″× 23 ⅝″ (73 × 60 cm). The no. 20 seascape format measures 28 ¾″× 19 ⅝″ (73 × 50 cm).

"I dislike the seascape format," Sarquella says, "because I find it too stretched out. I always paint, whether the subjects are seascapes or landscapes, in a figure format or a landscape format."

The central area of the painting (a figure format allows a lot of space above and below the central area) has been filled with a wide range of grays.

At the moment, in this color harmonization there is no predominant color, no pure color, no clean color, the grays complement each other through value and tone.

Now and then, Sarquella uses a fine, rounded no. 8 brush. He sketches in several boats in the background, in the upper right-hand part of the picture, and the buildings behind them.

"I try to simplify, to synthesize the reality I see," Sarquella says. He has no wish to be a slave to reality; he prefers the reality to be the inspiration for the painting he creates.

Sarquella likes to mix a lot of white with the colors he has on his palette: "I like to use a lot of impasto." The color harmonization achieved by the painter is due to the neutral colors, partly from the use of a lot of white and partly because Sarquella enjoys using intermediate tones to mix the colors together.

The artist uses the palette knife a great deal, to the extent that it could almost be called a combined brush-palette-knife technique.

At times, the palette knife even scrapes the thick paint left on the surface of the canvas by the brush.

Some painters begin by filling in the sky. Others, by drawing the motif. Still others, by staining the whole canvas with large spreads of color.

Sarquella has begun his painting in the center and progressively works, you might say expands, upward and downward. What is to be the main focus of the central part is fairly well defined, although it is not yet a detailed drawing.

You should observe the shapes and the colors as if they were an abstract painting, as objects such as the sea, the buildings, the sky, and the yachts, as if it were purely a relationship between the shapes and the colors.

At this point in Sarquella's work, the only empty, unpainted sections, where the canvas is still visible, are the small central areas to the left, and the sky and the sea.

Figs. 101 and 102. Sarquella uses white to lighten colors, a method which, as you may know, has to be done carefully or one runs the risk of turning the entire picture gray. Yet Sarquella also uses white as a color in itself, which is what it really is in oil painting, given the opaque nature of this medium. He uses white to paint the reflections in the water.

101

102

The painter cleans his palette: He sets the remains of the previous mixtures to one side and leaves a clear area ready for new mixtures. He changes the position of the easel slightly. Then, he cleans the brushes with a rag.

With such preparation, you suspect he is preparing something important.

But no. With the gold ochre mixed well with the sienna, he retouches the left-hand part of the buildings in the background. He reworks the area already painted, introducing slight modifications and new brushmarks. It seems as if he is hesitant to attack the rest of the painting, the parts that he has not yet covered. Contrary to other painters, who prefer to work all parts of the painting at the same time, and add detail later, our artist continues to work on the central part.

Little by little, however, as if on its own accord, the painting spreads out, moving upward and downward, like a small galaxy, a universe.

Sarquella has now covered almost the entire lower half of the canvas with thick impastos.

As you may know, one of the things that most concerns a beginner are reflections in the water. Watch how Sarquella firmly lays down the main reflections.

The lower section of the painting is full, but this does not mean that it is finished.

Gray is the predominant color—remember, it is the murky sea of a trading port—but note that it is not a uniform gray, there are many shades of gray.

Sarquella has also retouched the reflection of the first boat. A red line—made up of carmine and some sienna—has timidly appeared along the bottom of the boat: It is the first sign of a more or less pure color in this symphony of broken hues.

103

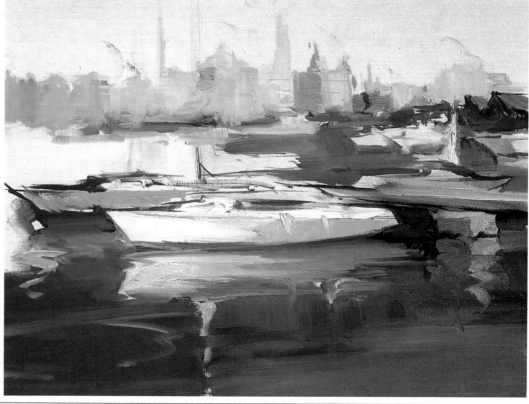

Fig. 103. Observe the noticeable differences between this stage and the previous one. Sarquella has painted the sea, and has filled in most of the white of the canvas with color. You can see that he has used only a little blue for the sea. Because he is painting in the port of a large city, the color of the water is affected by the gray, greasy oils emitted from the ships harbored there.

Fourth stage: defining the forms with paint

Sarquella begins by using a gray on the sky in the upper right-hand corner; in this case you might call it almost gray. With this fairly even gray, the painter begins to define the upper part of the buildings.

I have called it a fairly even gray, but notice how the right side of the sky is not the same as the left, which has noticeably more ochre.

At this point, the white of the canvas is only visible in the central left-hand side. Sarquella decides to take on this final section and covers it with thick impastos of white, sienna, and ultramarine blue—since Sarquella is using oils, the white of the canvas should not appear anywhere.

Sarquella glances now and then at the motif and applies brushstrokes on to the canvas. His method of application never appears systematic: a touch here, a touch there, without any apparent preconceived plan. He works according to the inspiration of the moment, which can only occur outdoors. The color of each object outdoors exists only in regard to the whole environment, the surrounding colors in which it is immersed. It was this factor that influenced the impressionists, such as Monet and Renoir, to paint outdoors.

As Pascual Bueno has stated earlier in this book, painting in the studio is always a more cerebral method.

Sarquella makes several changes in the water. What was before a blackish gray becomes a more bluish gray.

The canvas is now completely covered. From the colorist's point of view, the relationships have been established. The composition is also completely finished, the shapes sketched in. Now, only the drawing needs to be refined. You do not know how far Sarquella wishes to go with this. This is his decision and you already know that there are a lot of differences among painters concerning when a painting is considered finished.

Sarquella thinks about finishing off, detailing, and defining what is outlined. For the reflection of the boat on the water, he uses his thumb to spread the color. When

104

105

Fig. 104. Sarquella now outlines the shapes of the buildings with the gray of the sky, and at the same time is coloring in the only white parts left on the canvas.

Fig. 105. The artist doesn't overwork any one area of the painting. He gives a different tone to one, corrects another... Now, he is using his thumb to lighten the green reflection of one of the boats.

finished, the reflection is greener than before.

Sarquella glances quickly at the motif, looks back at the canvas, goes over the places already worked on, making substantial changes to the previous color.

Next, he wants to define the shapes of the boats, so he outlines them—Sarquella is very fond of outlining in paint. He works in from the outer parts of the boats, as he did with the buildings in the background when painting the sky.

The painter has continued to gently darken the sea, introducing new hues into the bluish gray of the sea. The dirty water of a trading port—a greasy, slimy sea—seems more suited to being painted in oils than in watercolors.

Figs. 106 and 107. Josep Sarquella continues to go over the reflections of the boats in the water. Painting reflections, which may appear difficult to many novice painters, does not in fact hold any great secrets. It is a question of reversing the shape of the object reflected, keeping the same lines of perspective, as if it was resting on a mirror. In seascapes, and in this one in particular, the mirror is the sea, an element in continuous movement that distorts the images reflected.

It is now past noon. Sarquella has taken off one of his jerseys, adds some paint to his palette, pours more turpentine into the oil bottle, and lights a cigarette.

Sarquella looks at his work and then backs away from it. He says nothing, but seems to be thinking: It's all there, all that's left is to bring it out.

The artist now concentrates on the formation of the small yachts, which are still missing their mast and spars. But he also works on the water.

He puts a color on the canvas, a sienna, but then regretting it, he recovers it with a gray.

Sarquella has quick movements: He looks at the motif, then at the canvas, makes a brushstroke, throws his head back to look again, makes another brushstroke, takes another look, and makes another comparison. All this is done at great speed.

The masts have been lightly sketched in with a gray.

106

107

Fig. 108. On finishing this stage, Sarquella has covered the entire canvas with color. He has worked more thoroughly on the sea, enriching it with various hues of gray, which have now turned more greenish. And he has painted the sky. It is an overcast gray sky, which harmonizes perfectly with the sea—as you know, the color of the sky is always reflected in the sea. As you can see from the photograph of the motif (fig. 89, p. 40), Sarquella's sky is not the same bright blue sky seen in the photo. The painting is a perfect example of an artist's interpretation of the motif. The range of cool tones used by Sarquella produces a calm, serene symphony: The sensation of a hazy trading port is transmitted to the painter.

108

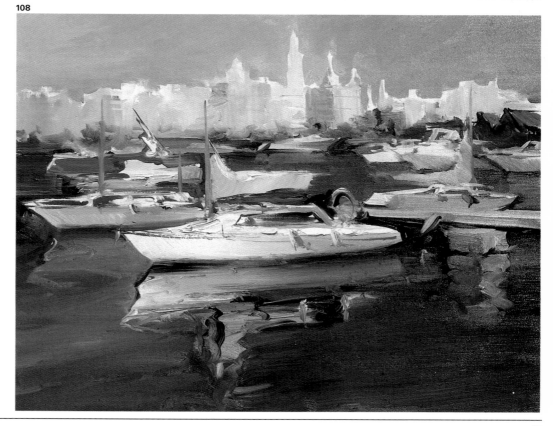

Fifth stage: shaping with a fine brush

With a fine rounded brush, the artist shapes the buildings in the background, which to many painters is the most difficult part of a seascape of this kind.

For this shaping, Sarquella mixes mostly violet with white and a little gold ochre, which results in a kind of mauve that he complements occasionally with sienna. At times, he works on the windows or the details of a building with a palette knife, and other times, he works with a brush.

"This fine brush," says the artist, "is made from ox hair." He only uses a fine brush for small details, sometimes alternating it with the palette knife, as you see in the photographs.

The brush has long hairs for greater pliability and flexibility.

The buildings in the background have now taken on more volume, more relief. Also the central shapes, the small yachts, have gained volume and clarity with this detailed work.

During this final stage, Sarquella turns his easel 90 degrees so that it faces the opposite direction.

"Because the sun is moving around me. Now, I even see the colors in a different way." Looking at the subject from his right, he finishes the masts and ropes of the yachts.

Sarquella finishes the spars and masts of the yachts, tracing white over the previous color and occasionally scraping the half-dried paint with a palette knife. The masts have finally lent their character to this city seascape.

Figs. 109 to 113. In the photographs at the bottom of this page and in fig. 113 on the following page, notice how Sarquella retouches and traces the details. He uses the palette knife to "open" the windows and relief of the buildings near the port, which up to now had been a warm, even background. Then, with a fine brush, he outlines the dome of a building and adds details to the masts and spars. With a thicker brush, Sarquella paints the reflections in the water.

109

110

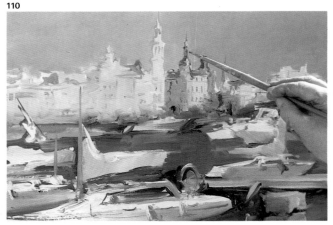

111

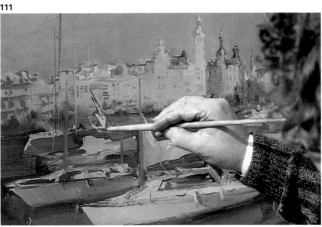

112

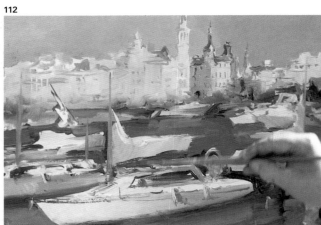

Fig. 114. Here is the state of Sarquella's seascape as the artist nears the final stage of this outdoor painting session of a port. As you can see, the painter has developed a cool color harmonization—capturing the atmosphere perfectly —which contrasts well with the warm buildings in the background and the masts that are outlined in white. Every painter has his own opinions about when a painting is considered finished. Sarquella is going to wait a few days and finish his painting in his studio.

You can also observe in the lower area of the buildings, where they meet the sea, that Sarquella has intensified the dark sienna color.

With this intensification, the buildings have a more solid basis; there is a heightened sensation of depth. A few lines with the ox-hair brush, an occasional bright note of red or yellow—that's it.

That's it? "My painting is forceful. I like to create contrasts, even violent ones at times, but I don't want to fall into sensationalism."

There could be nothing more removed from sensationalism than this symphony in gray—this harmonization of broken, mostly cool tones to depict a cold sky and a cold sea.

"But I'm taking it home with me," decides the artist, "to let it dry. I'll give it a few retouches when it's dry. I can't carry on now. I'll be ready for it in a couple of days."

What are the differences that he is talking about? Find out by turning to the sixth and final stage.

113

114

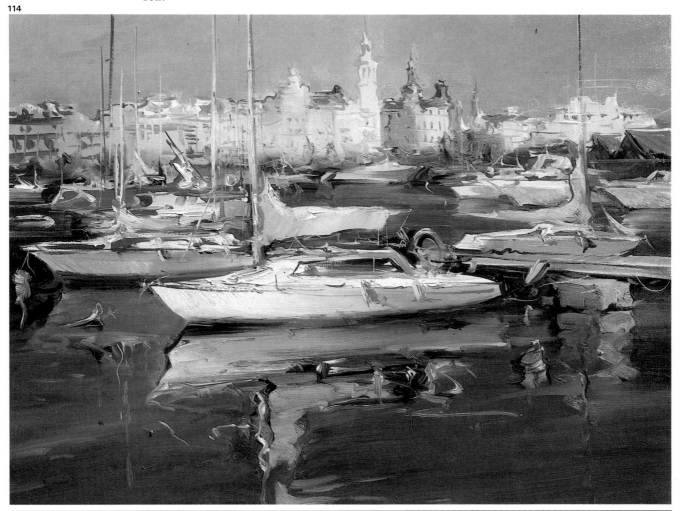

Sixth and final stage: artistic interpretation

Let's see what Sarquella has done in his studio to the dry painting.

I will begin from the top, with the sky. In the previous stage, it was an even gray, leaden-colored sky. It still seems to be a wintery gray sky, but now there are some light, pinkish clouds that enrich it considerably.

Let us move down to the buildings. Some new details were added to some of them, but look closely at the far left. The artist added some new rooftops, in order to liven up a corner that was previously "sinking" away from the composition.

On the yachts, the artist has done some minute retouching. These touches are very small, but not insignificant; each plays a part in the final effect.

Perhaps the most significant change can be found in the lower part of the painting. Make a comparison with the pier behind the first yacht. It was a cold gray. Now, it has been strengthened with ochre (above) and sienna (far right-hand side). On the column supporting the pier, Sarquella painted three white brushstrokes to increase the light.

And just below the pier, a grayish buoy that previously blended in with the sea is now red. In this simple way, Sarquella has found the warmth that his gray symphony needed: It is practically the same picture, only better.

Figs. 115 and 116. Compare the photograph of the motif on this page with the splendid final result of Sarquella's painting. There are two fundamental aspects that stand out: first, the interpretation of the motif as seen by the artist; second, the extraordinary synthesis of the atmosphere that surrounds the subject. From the start, Sarquella saw the large city port in a hazy light that transmitted the atmosphere of a misty morning. Therefore, he decided on a range of cool colors to contrast with the warm-colored buildings in the background. In addition, Sarquella has done a magnificent job of synthesizing and simplifying the elements of the motif included in this seascape.

116

115

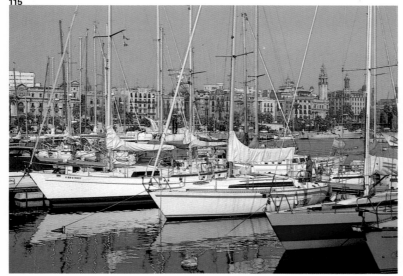

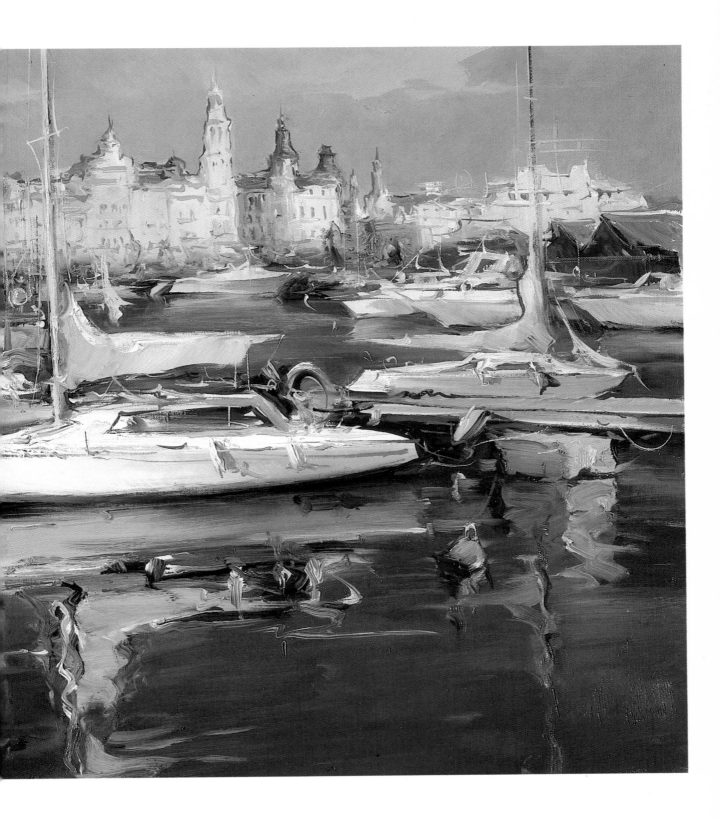

First, find and select

If you have the opportunity to paint in a seaport (preferably in the corner of the port, where the fishing boats are moored), the first thing you should do before setting up your easel is to see, to look, and to find without searching. "I don't search, I find," as Picasso would say. In a place such as a seaport, the subject and composition for a painting are simply there to be seen and found, as it should be.

I would even advise you to go three or four days earlier and take several photographs, as I did. This will help you to select the subject, to study the composition, to interpret the scene, and to select the range of colors you want to use.

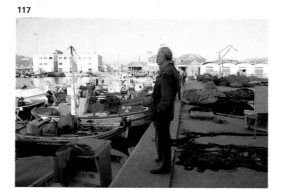

117

Figs. 117 to 123. A few days before painting this seascape, I went to the port of Barcelona and took several photographs. I later analyzed the photographs carefully in order to choose the best framing, the best perspective, and the best composition.

118

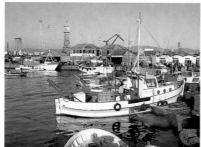

119

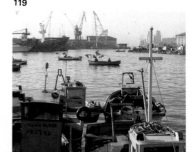

120

121

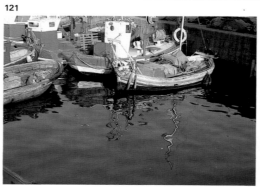

123

122

Now... to interpret, to paint *your painting*

Once you have chosen the place to set up your easel, you must decide what *your painting* will be like. Yes, for every motif, once the subject has been selected, the artist must study the composition, the framing, the contrast, the best way to represent depth, and the range of colors he is going to use. In other words, the artist has to interpret the *aspects of form and color* in the subject in order to achieve a personal vision of it, in order to paint *his picture*.

Much has been said and written about the art of interpreting a picture. The French teacher and artist Maurice Bousset has written: "Literal nature has nothing to do with art." Titian, Rubens, and even the classical painter Raphael interpreted much more than they copied. And the famous French artist Delacroix wrote in his notebook: "The landscape I paint is not entirely real," adding, "It is necessary to idealize, for the painter to introduce his ideal vision into the painting."

In an attempt to interpret the form of the

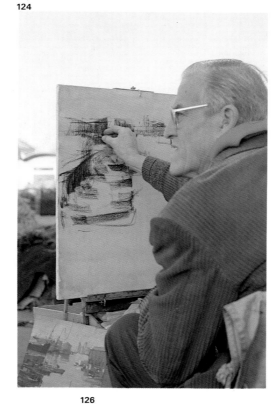
124

Figs. 124 and 125. I begin work on my painting. Although the scene is a horizontal panorama (fig. 125), I have decided to use a vertical format. I imagine a higher point of view that offers a broader perspective and a larger role for the sea.

Fig. 126. Here is a small-scale image of the finished painting so that you can compare it with the model and see the result of the interpretation of the subject.

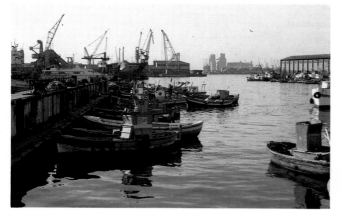
125

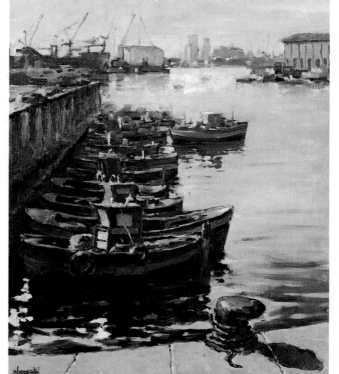
126

subject, I imagine a higher point of view, a view that would offer me a broader perspective, allowing for a greater emphasis of certain elements in relation to others; a point of view that would increase the role of the sea. I then thought of a vertical format.

This was my first step in the process of interpretation. Now, I must determine the range of colors.

Using a neutral color range

A few days before painting the final sea-scape, I went to the same place on the dock and painted the sketch that you see here. On that day, the sun and sky were half-hidden by the clouds. It was a gray day, with a gray-ochre tinge, with a range of neither cool nor warm colors but of grayed, neutral or "broken" colors, and I thought this would be the range I would apply to the final painting.

Three days later, when I went back to the dock to paint, the light and the colors had changed. But I had brought my color plan, or sketch, and a prepared canvas with a background painted in a mixture of ochre and white (with just a little ultramarine blue) and a lot of turpentine. I had already decided on the range of colors I wanted to use: It would be a *broken* range, leaning toward warm colors (see the box inset for specific colors).

127

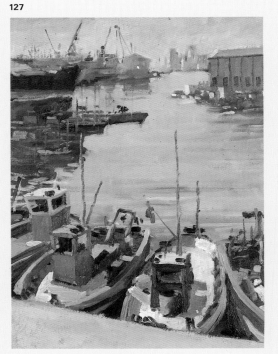

Fig. 127. A few days prior to painting the seascape, I went to the dock to paint this color sketch. I decided on a broken color range, leaning toward ochre and ochre-gray.

Fig. 128. Here is the canvas, which is painted with an overall layer of light ochre. At the foot of the easel is the sketch I painted a few days earlier, which I used as a guide.

Fig. 129. In this photograph, you can see the palette with the range of colors I used. With this color range, it is possible to obtain a range of broken colors, such as the one you can see on the palette used to finish the painting (fig. 147, p. 62).

128

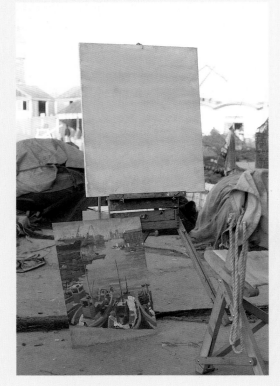

Range of colors

I will paint this picture with color range that is commonly used by professional artists.

titanium white	deep madder
lemon yellow	permanent green
cadmium yellow medium	emerald green
yellow ochre	dark cobalt blue
burnt sienna	dark ultramarine blue
dark burnt umber	Prussian blue
light vermilion	ivory black

129

First stage: the construction, the drawing

Below, I have transcribed several of my written notes: "Do a charcoal drawing. First draw the horizon line, a diagonal line that crosses from one side of the painting to the other, then add other sloping lines to represent the perspective. Draw several horizontal lines to indicate the approximate location of the boats. And finally, draw a few outstanding details of the silhouettes on the horizon and the shapes of the closer elements, to determine the overall structure—use faint lines, without any stainings or shadows."

And my notes continue:

"The second step consists of reinforcing the initial structure with a series of broad strokes. Use the charcoal laid flat— emphasize the shapes, draw with stains."

130

Fig. 130. The drawing begins with a very faint linear construction, barely sketched in, to proportion the elements that make up the composition.

131

132

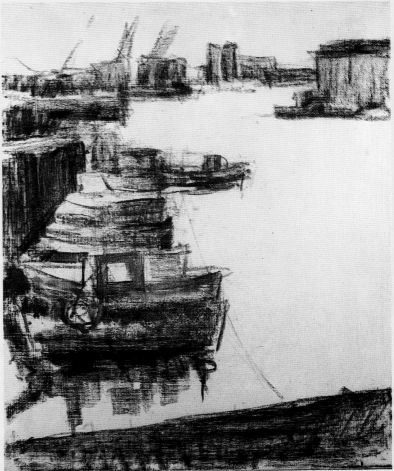

Figs. 131 and 132. Once the initial construction is finished, I stain the picture using the charcoal laid flat (fig. 131). In fig. 132, you can see the completed first stage of construction and drawing.

Second stage: general staining of the picture

133

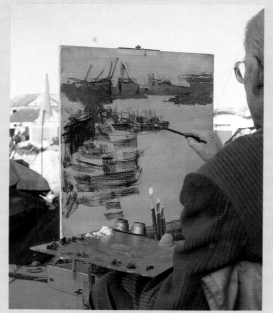

Fig. 133. With medium-sized bristle brushes, nos. 8, 10, and 12, I reconstruct, draw, and paint at the same time, using colors that come closer and closer to the definitive painting.

Before I begin painting, I spray the charcoal drawing with fixative. Then, while the drawing is drying, I spend a long time *observing* the subject. As Picasso once said, "Do you want to learn? Look, look around you." I look at the colors, the blues and dark greens of the boats, and realize that in order to obtain warm tones I must add burnt umber and sienna. There is a noticeable complexity in the shapes, and in the lights and shadows in the group of boats on the left. (This complexity has led me to decide: "I'll probably finish the picture in the studio," I say to myself.)

Now, I begin to paint. With grays and broken colors mixed with a good deal of turpentine, I have the initial idea of staining all the shapes, without painting the sky or the sea for the moment. I apply *very thin* layers of paint stains, which are similar to the shapes and the colors of the model. The colors have a tendency to dirty so I cover the canvas with gray, without holding onto specific shapes.

Something Eugène Delacroix once wrote sums up the ideas behind this second stage of the painting: "I am never in a hurry to get down details. First, and above all, I concentrate on the large masses of color and the general character of the painting; once these have been established, I experiment with the subtleties of shape and color. . . I go back over the painting constantly, freely, without any systematic method."

Yes, this is the first stage for capturing your initial impression, to set down the first image of your color interpretation of the painting.

134

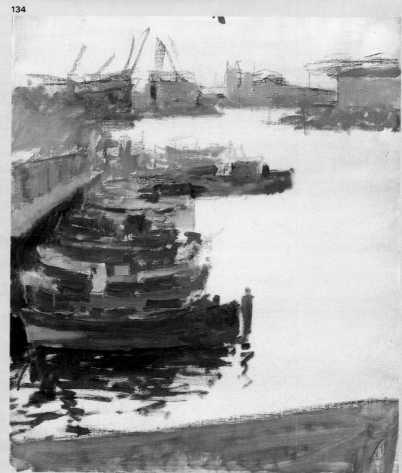

Fig. 134. Here is the painting in the second stage. There is a general staining of color that defines and situates the main shapes and begins to develop the color tones.

Third stage: general tones

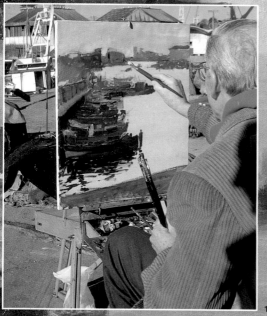

Figs. 135 and 136. Once I paint in the sky and the sea, the painting begins to acquire a certain fullness. In this stage, the painting is like an advanced sketch, which enables me to check the general coloring.

135

136

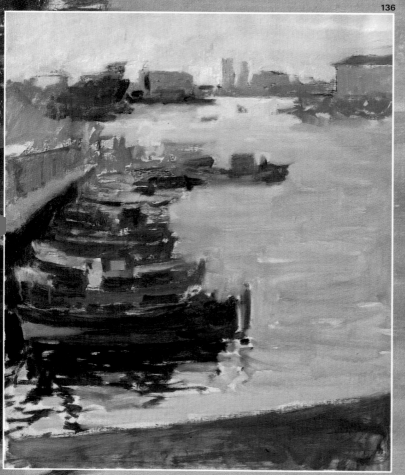

In this stage I will paint the sky and the sea (fig. 135).

Over the light ochre-gray background color of the prepared canvas, I am now going to paint with an even lighter gray ochre. But notice that it is not an even color, and not an even background. Instead, there is a range of colors, and the horizontal brush-strokes give constant variations to the general color of the sea, with a tendency to darken the overall tonality of the sea as it stretches into the foreground.

You should also note that in this undefined way, the background color draws, corrects, and defines the shape of certain items on the horizon, creating a vague, general vibration. By painting in the sky and the sea, I have also filled in the tone of the canvas and decided on a general, but unspecified, range of colors for the painting.

From this point on, I can emphasize the contrasts, work on the lights and shadows, and define and synthesize certain shapes or elements, but the range of colors will stay the same—a chromatism of warm, neutral, broken colors.

Notice in this third stage the pronounced contrast already hinted at between the reflections and the boats in the foreground, and the objects located further away. Also note the deliberately weak coloring of the boats and the most distant buildings. On this subject, I suggest you reread page 14, which explains the fundamental formula for atmosphere: The more distant planes should be more lightly colored while the foreground should be more heavily contrasted.

Erasing, rectifying, redrawing, repainting

Figs. 137-139. Rectifying, erasing... can appear to be a complex operation when painting in oil, but it does not really present any major problems. You must not hesitate in doing it if necessary. In this case, it was a question of erasing the general confusion of forms and colors in the boats of the foreground, as well as redrawing their basic forms.

It is not advisable to paint continuously, without a break, without stopping or observing. The expert artist knows that, now and again, he should leave the painting, put down the palette and the brushes. . . talk to a friend, smoke a cigarette, have a cup of coffee. He should do something that allows him to be physically and mentally removed from the painting, from the model, so he can return later and see the subject as a fresh image and be able to look at the painting with a better spirit of self-criticism.

When one looks back over the work already done, one should not be afraid—I have said and repeated this a thousand times—to erase, to rectify, to redraw, to repaint. Since oil is an opaque medium, you can always *repent,* or correct. When I reviewed my work in this painting, I saw it was necessary to explain the shapes of the boats more clearly. Without thinking twice, I soaked a rag in turpentine and erased the foreground of boats (figs. 137 and 138).

Later. . . with a rounded no. 8 sable brush, a thick dark coloring—dark burnt umber and ultramarine blue—and plenty of turpentine, I drew over the erasure with a

137

138

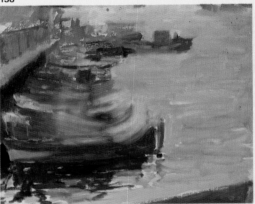

139

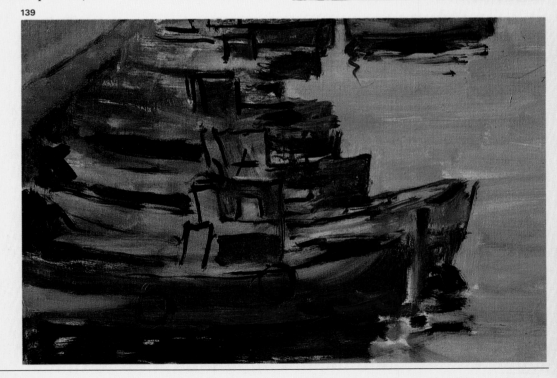

series of strokes, a synthesis of the most out-standing shapes of the boats. At the same time, I rectified the length of the second boat by making it larger and longer than the first boat, and I defined the shapes of the remaining boats (fig. 139). Then with round, flat bristle brushes, nos. 6 and 8, and plenty of paint, I immediately repainted the planes of the wheelhouses, the sides of the hulls, the handrails, and the tires tied to the first boat in the foreground. Lastly, I worked on the dark stains which were to be the reflections in the water and began to think about the final touches. At this point, I remembered the previous stage, prior to erasing, and

wondered whether it would be better to leave the painting as it is, thinking it might be more spontaneous, less finished, fresher. Then a remark by Picasso came into my mind. He once said, half-seriously, half-jokingly, "A *finished* painting is a *dead* painting."

There I was, thinking and doubting, when suddenly I realized my mistake, an enormous and unforgivable mistake for a professional artist.

140

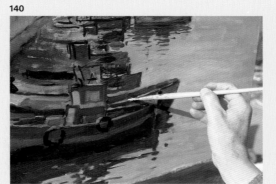

Figs. 140 and 141. With medium-size brushes, I outline the edges of the shapes; this is a task that I carry out constantly until I finish the painting.

141

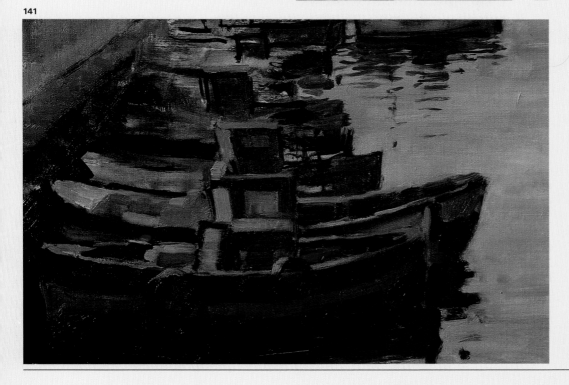

An error discovered at the last moment

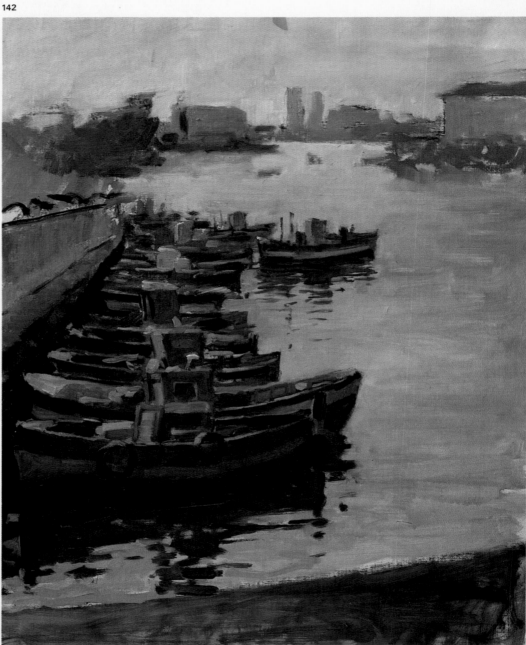

142

Fig. 142. With the painting at an advanced stage, near completion, I was thinking about finishing it, but then I suddenly realized that I had made a major mistake in the perspective. The solution is explained on the next page.

Compare the viewpoint of the painting as it appears in this illustration (fig. 142) to the three diagrams on the following page (figs. 143 to 145). These visuals will help you see more clearly than words the error I discovered at the last moment when the painting was nearly considered finished: a serious error in perspective. Can you see it?

Well, I could excuse myself by saying that it was the result of changing a basically horizontal composition into a vertical one (figs. 139 and 141 on pp. 58 and 59).

I could also say that the artist can afford this luxury... but I won't; the artist may bend the perspective but he should not get it wrong. And here the mistake is obvious.

A serious error of perspective

In a seascape with the sea as the main focus, the horizon line is unmistakable: It is the highest level of water that you see when you look straight ahead at eye level. The vanishing points meet on the horizon line (only one vanishing point in this case, as it is a parallel perspective) where the parallel lines perpendicular to the horizon meet. In my painting, the parallel lines *vanish* at a point located under the horizon line (fig. 143, WRONG).

I rectify, rearrange, and repaint the dike (fig. 144, RIGHT). But I should tell you more about the problem of perspective in this image: The regular, or symmetrical, separation of the shapes on the dike poses a problem in perspective which is called *division of spaces in depth*.

In order to correct this problem, see Fig. 145, which graphically explains the process: First, the vanishing point for the diagonal lines is established on the horizon line, then the vertical lines of the dike are added (A). Next, the earth line is drawn, starting from vertex B, forming a right angle with the first vertical line. A line is then drawn—from the diagonal line's vanishing point—level with the last vertical space (C)—to the earth line, which gives me point D. Now, only the earth line from B to D needs to be divided into the number of shapes or spaces seen in the model, in order to create the vanishing point of the diagonal lines, or the division of spaces in depth.

Complicated? Yes, perhaps. Necessary? Yes and no. The artist must know and be familiar with these elementary formulas, or as van Gogh once said, "He will never create." I believe an artist must know about the *division of spaces in depth* in order to draw and paint freely.

143

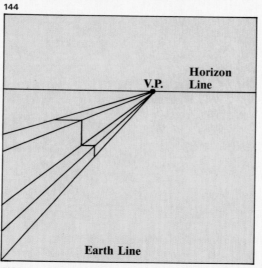

Fig. 143. WRONG. The mistake in perspective is obvious: The vanishing point of the dike on the left does not reach the horizon line.

144

Fig. 144. RIGHT. The actual location of the vanishing point forces me to modify the structure of the dike; the upper part should be in higher position.

145

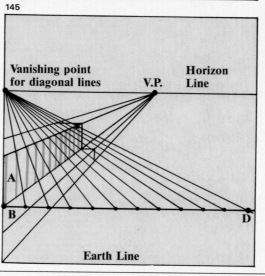

Fig. 145. RIGHT. For those keen on perspective, here is an example of the *division of spaces in depth*. The professional artist can solve this problem by sight, but he needs to know the formula as shown in this illustration.

The finished painting

I rectified the perspective error, worked on the background, and painted practically nothing else.

Some hundred years ago, all paintings, even landscapes, were painted in the studio. The impressionists painted outdoors, in the open air, but many if not most of them finished their works in the studio: "Claude Monet," explained Pierre Bonnard to Angèle Lamotte, a journalist and critic, "painted with the model in front of him, but only for a short period of time. He did not let the model take over." And Bonnard confessed, "I only paint in my workshop, because the starting point for the painting is an idea and if this original idea fades away, there only remains the model to invade and dominate the painter. . . who finishes by accepting chance and paints the shadows he has before him or some detail that did not interest him at the beginning. . ."

Yes, working or finishing off a painting in the studio has its advantages, especially nowadays when you can photograph the model and have a graphic reference. But, be careful! It is never advisable to copy from a photograph.

In the calm and comfort of working in my studio, away from the cold, the wind, and the onlookers, I turn my attention to solving three fundamental aspects of my seascape:

a) *The composition or graphic layout.* If you compare this final stage with the previous one (p. 60), you will see that I changed the lengths of the first four boats in order to break the monotony of the previous perspective. You will also see that I have added a mooring post in the foreground to the right; it adds reflections and marks in the water and enhances the diagonal composition. The classical diagonal composition, which Rembrandt used frequently, divides the picture diagonally, with one part dark and the other part light (fig. 146).

b) *Emphasizing the third dimension.* This caused the most work. Working on the foreground area, I emphasized as much as possible the contrast of the nearest shapes and the mooring post. I lightened the foreground

line of stones, painted and repainted, adjusted colors and tones, grayed colors, and paled the colors as they receded into the distance.

c) *Balancing and maintaining the broken color range.* After I had finished these two sessions of work in my studio, I asked the photographer to take a photograph of my palette. Notice how a normal color range (see fig. 129, p. 54) can become a range of grays, a range of neutral, broken colors (fig. 147).

I do not come close to the quality and genius of a Manet, a Monet, or a Bonnard, but it is good to follow their example, their advice as in this case where finishing the painting at home is more efficient, more thrilling, more fun.

Fig. 147. Here is my palette after finishing the painting. Notice the range of colors obtained from the mixture of a traditional set of colors, as seen in fig. 129, p. 54.

Fig. 148. In the finished painting, I have emphasized three fundamental aspects: the diagonal graphic layout (fig. 146); the illusion of depth by contrasting the foreground and background, and by paling the objects as they receded into the distance; and the color harmonization—a broken color range ending with ochre-gray. I began by using some blues mixed with burnt umber and white, or a mixture of complementary colors in different proportions, which I later turned into grays by mixing with white.

148

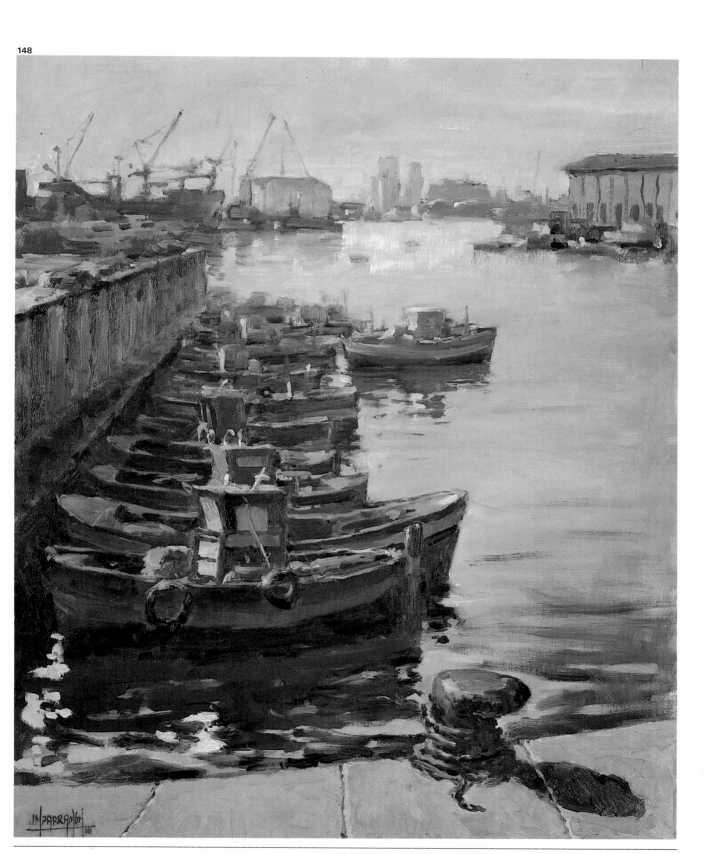

Contents